NORTH ITALIAN PAINTING
OF THE CINQUECENTO

NORTH ITALIAN PAINTING
OF THE CINQUECENTO

PIEDMONT · LIGURIA · LOMBARDY

EMILIA

by

CORRADO RICCI

Hacker Art Books
New York
1976

First published Florence, 1928.
Reissued 1976 by
Hacker Art Books, New York.

Library of Congress Catalogue Card Number 75-11064
ISBN 0-87817-171-1

Printed in the United States of America.

7

6

CONTENTS

LIST OF PLATES

THE TEXT

Some of the anecdotes collected by Vasari may not be true, or they may be true in part only; but they at least afford us an insight into the struggle which at the beginning of the sixteenth century was in progress between the disciples of the new school — or rather, the exponents of the so-called «modern» style — and those others who remained faithful to the traditional methods of the fifteenth century. More than that, they show how great must have been the consternation of the older artists, who recognised that their own work had been surpassed, yet realised that they had lived so long and had become so wedded to their own technique that they were incapable of abandoning the old tradition and still less fitted to adopt the principles by which the new school was guided.

The most characteristic of these anecdotes is one which refers to Francia. Vasari relates that Raphael, after painting a picture of « St. Cecilia », sent it to Bologna, and appealed to Francia « as a friend » to find out if the work had arrived in good condition, « begging him, in the event of the picture having been scratched in transit, to repair the damage and at the same time to remedy any defect he might discover in the work itself ». Highly delighted at this mark of confidence on the part of the young but already famous artist, the old painter of Bologna set to work to remove the picture from its case; but when it stood revealed in all its brilliance of colouring, its breadth of treatment and its splendid vitality he stared at it in amazement, realising that all his ideals had suddenly suffered shipwreck. « Greatly distressed by this sudden awakening to reality, haunted by the beauty of the picture and going about his business like one in a dream, he caused the work to be placed as quickly as possible in the chapel at San Giovanni in Monte for which it had been designed. Then, deeply humiliated to find that his own imagined superiority as an artist had been but an idle dream, he took to his bed a few days later and, as some say, died of grief and disappointment ».

This anecdote, reminiscent of another told by Vasari to the effect that Verrocchio laid down his brushes for ever after he had seen one of Leonardo's angels, fails to pass the test of chronology, for Francia did not die until more

than a year after the « St. Cecilia » had been sent to Bologna. It is, however, full of significance, for if it is not actually a precise record of fact it nevertheless reflects « a state of mind ». In this connection it is worth while to remember that when Michelangelo was in Bologna modelling the statue of Julius II he saw one of Francia's children, a lad of singular beauty, and remarked with bitter sarcasm: « Well, your father is a far better hand at making beautiful people than at painting them ».

But before Michelangelo and Raphael came to Emilia to reveal the « new manner » Leonardo had already painted his « Last Supper » in Sta. Maria delle Grazie at Milan and had produced other notable works which not only exhibited all the highest qualities of the work of the fifteenth century but combined with them an absence of artificiality in the grouping of the figures, greater regard for anatomy and the just proportions of the human form, relief obtained from the play of light and shade, and, finally, a softness of outline by means of which the figures appear to blend with the background; in all these things revealing the new lines along which pictorial art was developing.

Leonardo came to the court of Lodovico Sforza in 1482, having already given signal proofs of his genius before leaving Florence. He had served his apprenticeship to art in that city in the studio of Verrocchio, the painter and sculptor; and there, for the extra-urban church of Monte Oliveto, he had painted the « Annunciation » which is now in the Uffizi, and had begun an « Adoration of the Magi » for the friars of San Donato at Scopeto. This picture, although it is little more than sketched out, is perhaps the most precious of all the paintings in the Uffizi, and reveals all the peculiar qualities of the master which are to be found in his later works. It is clear and harmonious in composition, enchanting in its beauty of facial expression; its figures are alive and bear eloquent witness to the emotions aroused in them by the presence of the Holy Child.

What was it that induced Leonardo to leave Florence? Was he discontented because Lorenzo the Magnificent took more interest in other artists — men who were apparently more productive and more anxious to please than

himself? Was he attracted by the greater splendour of Sforza's court, so much better suited to his refined nature and offering larger rewards to men of ambition? Was he perturbed at the envy, jealousy, scorn and derision which at that period impregnated the artistic atmosphere of Florence? Perhaps it was all these together.

What is certain is that we must number him among those great geniuses whose versatility, whose immense activities in a score of directions, were not at once appreciated at their full value; whose defects and short-comings received but scant sympathy. He was not the exponent of an art, but of art itself. It mattered not a whit whether that art found expression in beauty of form or in the solution of a scientific problem. The ideal for which Italians have always sought — particularly during the Renaissance period — of a perfect man endowed with universal ability; or, let us say, a man complete in all the attributes of life and thought, had never before, and has never since, been so admirably exemplified as in the case of Leonardo. He was equally attracted by the secret processes of nature and by the manifestations of human ingenuity. It was his delight to watch, to examine, to sift, to understand; and it was perhaps just this multiplicity of interests which in many cases prevented him from carrying out his undertakings. In a word, it was this that prevented his finishing his work. As a result, his contemporaries regarded him as lazy and irresolute, a reputation which survived long after his death. Today, when acquaintance with his voluminous writings has revealed the wide range of his activities, and study of his pictures has made clear his perfect mastery of technique, form and expression, such accusations are inconceivable. And yet Vasari, many years after his death, wrote him down as « changeable and unstable », and accused him of having « begun many things » and « finished none of them ».

He was fully aware of his own versatility. When offering his services to Lodovico il Moro he told him that he knew how to construct engines for use in war, impregnable fortresses, and offensive and defensive works both by land and sea. « In times of peace », he said, « I believe myself capable of serving

you in the matter of designing beautiful public and private buildings as satisfactorily as any other architect, and I am ready to convey water from one place to another». Passing to matters more purely artistic, he continued, — « I will carry out works in sculptured marble, in bronze, in clay or in painting that will bear comparison with the work of any other craftsman, be he who he may». These are words — especially the last — which would appear presumptuous on the lips of any other man, but which, spoken by him, evoke our entire agreement, much as Dante and Manzoni evoke it when they proclaim the immortality of their own work.

It is impossible to imagine that Lodovico Sforza, nicknamed the « Moro », anxious as he always was to add to the lustre of his court, should turn a deaf ear to an artist who combined outstanding ability with personal dignity and refinement of character; a man who was « endowed with such qualities of mind that he carried whatever work he might happen to be engaged upon at the moment to a pitch of excellence beyond the reach of any other human being ».

Francesco Sforza, the great *condottiere* and able statesman who had risen to be Despot of Milan by virtue of supreme military talents and more than ordinary astuteness in political matters, had been succeeded in 1466 by Galeazzo Maria. The latter, however, was killed some ten years later as the result of a conspiracy, leaving his little son and heir, Gian Galeazzo, to the care of his own mother, Bona of Savoy, and the governance of the state to the wisdom of Cicco Simonetta. It was not long before Lodovico appeared upon the scene, intent on seizing the power and holding it. To this end he first sowed discord between Bona and Simonetta; then beheaded the latter and shut up the former, together with the delicate little heir, at Abbiategrasso.

Had it not been for a bitter quarrel which broke out between his wife, Beatrice d'Este, and Isabella of Arragon, wife of Gian Galeazzo, Lodovico might have lived in tranquil enjoyment of the possessions so ably consolidated by the valiant Francesco. Isabella, however, could ill tolerate the usurper, and the Moro, fearing that the Arragonese might intervene in favour of the right-

4

ful heir, invited the King of France to undertake the conquest of Naples. Thus it was that the foreigner first came into the land; and thus it was that Lodovico, having earned for himself the title of « the Great Betrayer of Italy », was vanquished by his own French friends at the battle of Novara, was taken prisoner and sent to languish and to die in the castle of Loches!

« Terrible were his crimes », but the historian must yet render homage to his magnificent qualities as a prince. Studious, generous, just, he raised Milan to such a height that she rivalled the other courts of the Renaissance, while at the same time he gathered together a crowd of men of the highest attainments in every branch of knowledge; historians, poets, learned men, scientists and musicians, although the presence of Leonardo alone would have sufficed to secure for him eternal glory, even as the presence of Dante Alighieri in Polenta has made the lords of that city famous. And then the whole fabric falls to the ground, rent from top to bottom as the result of a policy which led him into unexpected complications and left him to be the prey of the wild beasts he had himself stirred into motion. Bramante sets out on the road to Rome, while Leonardo and the mathematician Luca Paciolo turn their faces towards Florence.

Nearly the whole of Leonardo's life between 1449 and 1506 was spent in the latter city, although it is true that he visited Venice during that period and also was employed as architect and military engineer by Cesare Borgia first in the Marches and afterwards in the field against Pisa.

While in Florence he designed the cartoon for the « St. Anne with the Virgin and Child » now in London, and another picture representing the same subject now in the Louvre. He also began the « Battle of Anghiari » in the Sala del Consiglio of the Palazzo della Signoria, and painted the portrait of « Monna Lisa del Giocondo », while it was perhaps also at this period that he painted the « St. Jerome in the Desert » now in the Vatican Gallery and other pictures which have since disappeared. But Florence had in no wise changed since 1482, and Leonardo, who had never liked the city, must certainly have welcomed the invitation of Charles d'Amboise, the French king's representa-

tive, to return to the ebullient city of Milan, despite the fact that the Signo-ria of Florence wished to detain him until he had finished his picture of the « Battle of Anghiari ». He returned to Milan and remained there ten years — for throughout his occasional visits to Tuscany, Emilia and Rome Milan con-tinued to be his permanent domicile — and left it only when François I drew him to France with the offer of a more generous provision. There he accom-plished but little, for the sands of his life were fast running out. In April 1519 he made his will at Cloux near Amboise, and there, on the 2nd May, he died.

<div align="center">★</div>

The two pictures by Leonardo which made the greatest impression on the painters of Lombardy and turned their thoughts into new channels were the « Last Supper » and the « Virgin of the Rocks », painted during his first stay in Milan.

Two copies of the « Virgin of the Rocks » were available to Leonardo's friends and disciples, one of them (now in the Louvre) entirely by his own hand and the other — which differs slightly in certain details — painted later in substitution for the first by Leonardo and Ambrogio de Predis together. The later work was intended for the Chapel of the Fraternità della Concezione, and hung there until nearly the end of the eighteenth century, when it was removed to London. No other conclusion as to the relative value of these two pictures seems possible in the light of the available documentary evidence.

Leonardo certainly painted the first picture, and painted it for the Frater-nità; then, when the question of the price to be paid seemed unlikely ever to be settled, the artist accepted the offer of some important personage (Louis XII?) and sold the picture. At a later date he made a somewhat freely treated copy for the Fraternità, being assisted in this work by the pupil who painted the two angels at the sides. It is a fact that the version now in Paris had already at a comparatively remote date found its way into the possession of the French king.

The « Last Supper » was painted by Leonardo between 1495 and 1497. It was painted on the wall in hard tempera and fixed with a resin varnish. We are

indebted to Bandello for the following strange notice. « I have often watched Leonardo, whose habit it was to go early in the morning on to the scaffolding which was rendered necessary by the fact that the « Last Supper » is painted some distance up on the wall. He was, as I have said, accustomed to remain there from sunrise to twilight, painting continuously, never once putting down his brush, oblivious to hunger and thirst. Then three or four days would pass without his once handling a brush, although he would remain there for one or two hours contemplating and criticising his work; examining, weighing and judging the figures he had created. And I have also seen him at mid-day when the sun was hot, compelled by some sudden caprice or fancy to leave the courtyard in which he was modelling his stupendous horse and hurry away to the Grazie, climb on to the staging, sieze a brush and put a few rapid touches to one of the figures, and then as hurriedly step from the boards and betake himself elsewhere ».

It is almost unnecessary to refer to Leonardo's other achievements in Milan; his designs, his portraits, his painting, his decorative schemes, his projects for civil buildings and churches; his plans for canals and fortifications, his reports on problems of statics, his scientific studies and researches, his vast plastic conceptions such as the colossal equestrian statue of Francesco Sforza (the « stupendous horse » mentioned by Bandello) so callously destroyed by French archers during the war that heralded the final downfall of Lodovico.

But for our present purpose the two celebrated paintings to which reference has been made are of outstanding importance. They are the fountain heads from which the Lombard followers of Leonardo drew their inspiration and the models which they copied *ad nauseam*. From the « Virgin of the Rocks » came their sombre-toned rocky backgrounds, their angels, their gently smiling Mothers, and their flabby — one cannot call them dainty — children; from the « Last Supper » the characteristically rugged faces of their old men and the shapely contours of their youths. Yet with it all they were incapable of reproducing either the harmony of design that distinguished the work of Leonardo or the alluring grace of his groups, which, although isolated, are never-

7

theless knit together into a single composition by the subtle suggestion of bodily gesture and facial expression. Still less were they capable of understanding the spirituality and poetry of his figures and landscapes, or, for that matter, of any of the inspirations he draw from nature and, as Vasari says, expressed in so divine a manner.

Qualities such as these could not be transmitted to others. They remain the attributes of the individual together with his personal virtues and characteristics. The pupils and followers of a great master can at best only acquire the externals of his teaching: their work may bear a general family likeness to his, or it may exhibit no more than a similarity of technique.

It therefore not infrequently happens that, unable to imbue others with the indefinable qualities which distinguish his own work, a genius such as Leonardo becomes a disturbing influence. Whoever is attracted into his magic circle is lost, in that he is forced to surrender that modest personality of his own which might have given his unfettered work a certain degree of distinction. For this reason we consider that although the art of painting in Lombardy was profoundly influenced by Leonardo's example, that example was not really beneficial.

At the time of his arrival in Milan the field was held by a group of artists who, while inferior to the painters of Venice, Tuscany and Emilia — and especially inferior to the Ferrarese group — produced works which possessed a certain amount of character and originality. Civerchio was one of these; and Butinone, and Zenale, and others. In the forefront stood Foppa, Bergognone and Bartolomeo Suardi called « Bramantino » — possibly because he was inspired by Bramante, who, coming to Milan as a painter before the arrival of Leonardo, remained to lay aside his palette and to win immortality as an architect. The work of these men is accurate and austere, yet it shows that the school was animated by a spirit which accorded perfectly with the physical characteristics of Lombardy. It does not rival the richness and vigour of the Venetian school nor the bold modelling of the Ferrarese; it has neither the elegant virility of the Florentines nor the sweetness of the Umbrians; but it is

8

endowed with a devout and gentle melancholy, and there is an earthy pallor on the faces of its men and women that makes us feel that we are looking at them through the silvery haze that haunts the Lombard plain.

Be it said to their credit that this noble little band remained faithful to its principles. Foppa and Bergognone continued to paint in the precise Lombard tradition of the fifteenth century even after Leonardo had finished his « Last Supper », when Michelangelo had completed the ceiling of the Sistine Chapel and Raphael had uncovered his work in the Camera della Segnatura. And when, later, Bergognone produced his timid alter-piece for Nerviano, Titian had already painted his « Assumption » and Correggio, having completed the decoration of the Camera di San Paolo, was at work on the dome of San Giovanni Evangelista!

But it is not a matter of great importance. The sincere, honest work of these painters is judged today on its own merits and not in relation to the period in which it was executed. Viewed from this angle it is entirely admirable on account of its spontaneous sincerity.

But the same cannot be said of the band of artists who set themselves to follow in Leonardo's footsteps, exaggerating his methods of treating light and shade, elaborating his landscapes, and endowing every face with, as it were, a stereotyped copy of that smile which some facile orator or poet has for some unknown reason dubbed « enigmatic ».

It must not, however, be thought that the school of Leonardo was entirely without merit or that it produced no painters of distinction. The position is quite otherwise; but there is no longer any question of a purely Lombard inspiration, or of artists imbued with originality of conception — still less is it a case in which the influence of the master derives added lustre from the work of his followers. Before Leonardo, the painters of the great city were not especially distinguished, but their work was free and unfettered; the painters who came after him worked almost as if bound hand and foot by his example.

Let us enumerate the chief of them. The first in chronological order was Andrea Solario (1460-1515), a member of an ancient family which had pro-

duced many artists and brother of Cristoforo called « il Gobbo ». Although in architectural design Andrea adopted the methods of Bramante he became in sculpture an ardent admirer of Leonardo, endeavouring to acquire a freedom and grace of treatment that was foreign both to his temperament and the Lombard tradition and finishing by producing figures that were bloated and enervated.

As a young man he had worked with Alvise Vivarini in Venice and had there drawn inspiration from the pictures of Antonello da Messina and other brilliant colourists; but this did not save him from being drawn into Leonardo's circle. He had no particular gift for composition and he never attempted large pictures, but it cannot be denied that those of his devotional works which contain only one or two saints, and especially those portraying a single figure, are imbued to a notable degree with an atmosphere often pensive and sometimes sad. His best work is to be seen in the grief-stricken figures of his « Ecce Homo » and in the sorrowing bystanders of his « Christ carrying the Cross ». It must further be conceded that his portraits show a certain degree of power in the representation of facial expression, although his modelling is not always either restrained or sure.

There are some who consider that Giovanni Antonio Boltraffio (1467-1516) was a better artist, although his paintings betray the same weaknesses of composition that are present in the work of Andrea. Yet it must be admitted that his figures are better modelled and more impressive, and that there is more life in his treatment of light and shade. A notable quality in his work is his practice, when painting flesh, of distributing high lights over the whole of its surface, a practice which sometimes gives to his work a certain resemblance to that of Piero di Cosimo. He, likewise, is more successful in his portraits than in works containing several figures. The reason is not far to seek. An artist who is not endowed with the divine faculty for creating things that are unreal is likely to be far more successful if he confines his attention to concrete realities and endeavours to impart nobility and dignity to his subjects. In this Boltraffio was an adept.

Among the many who became Leonardo's followers were Ambrogio de Predis, who lived between 1450 and 1520, was an excellent portraitist, and collaborated with Leonardo on the second version of the « Virgin of the Rocks »; Francesco Melzi (1492-1570?) in whose arms Leonardo died and to whom he bequeathed many of his possessions; Bernardino del Conte, whose work is poor and faulty; Gian Giacomo Caprotti of Oreno, nicknamed « Salai », who followed his master from Milan when Lodovico fell from his high estate; Marco d'Oggiono (1470-1527), a painter without ideals, heavy in his colouring and a faulty draughtsman — very different from Cesare da Sesto (1477-1527) whose figures are often pleasing and whose compositions are well balanced; Gian Pietro Rizzi, called Giampietrino, who flourished in the first third of the sixteenth century and showed a certain grace of execution in one or two smaller pictures of the Holy Family, but over-emphasised his nude figures of Lucrezia and the Magdalen, both of which are tiresome and wooden in form and colour; Cesare Magni, who was pallid and trivial; and Francesco Napoletano, who dealt in violent contrasts of light and shade and painted all his faces as though they were swollen.

All of them must have known the proverb « he who follows others will never get in front », but it was not in them to take the lead. There was not one of them who earnestly sought to hew out a path for himself, or turned in faith and hope to the old Lombard masters, seeking a local tradition which could be cultivated and made to bear fresh fruit. They preferred to gather up the crumbs that fell from Leonardo's table, and for that reason — the truth must out — the Lombard school of Leonardo was never more than second-rate.

Hailed as one of the most brilliant of all the painters of the Lombard school and numbered among the pupils of Leonardo, it might seem as though the name of Bernardino Luini (1485?-1532) gives the lie to the foregoing statement.

Luini was undoubtedly a painter of great merit, but his place is not among the greatest of all. Furthermore, he cannot be considered a follower of Leonardo, as he came originally from another school flourishing in Milan at the same time; and if his work reflects the charm of Leonardo's it does so without

any sacrifice of the artist's own individuality. His relationship to Leonardo is the same as that of Sodoma and Gaudenzio Ferrari.

His first artistic inspiration was drawn from Bramantino and therefore, though indirectly, from Bramante. From them he derives his breadth of decorative treatment, his pale rosy tints and his masterful handling of fresco. Leonardo, it must not be forgotten, never painted in fresco, nor did any of his followers. Fresco as a medium was commonly adopted by the old Lombards, such as Foppa and Bergognone, and by Bramante, Bramantino and Luini; but it was never (or hardly ever) employed by Melzi, or Bernardino dei Conti, or by Salaì, or Marco d'Oggiono, or Cesare da Sesto, or Giampietrino, or Magni, or Francesco Napoletano, or by any of Leonardo's followers. It is true that frescoes were executed by Boltraffio, but it was from Bramantino and from Bergognone that he learnt how to handle that medium.

It has long been known that the « Last Supper » was not executed in fresco, and it was therefore assumed to have been painted in oil: but Luigi Cavenaghi, who in 1908 was commissioned to repair it and to study its technique very carefully, reported as follows. « I am obliged to correct my former opinion that in the « Last Supper » Leonardo had used oil as a vehicle for his colours, which was in agreement with the statement made by Lomazzo and by many other artists after him. I was led to this conclusion by the characteristic shrinkage of the pigment and by the brilliance derived from the generous use of size. As a matter of fact, none of the portions of the work examined by me show any signs of the presence of oily substances, and I have further satisfied myself by a careful examination of the upper portions of the picture, and more particularly of the delightful lunettes above it, that the work is much better preserved where the vehicle originally employed has had less chance of drying out entirely. Leonardo therefore painted the « Last Supper » in hard tempera, experimenting with new methods and preparations which, to judge from the present deplorable condition of the work, must have shown signs of failure within a few years after the painting was finished ».

Nor did Leonardo employ fresco when he painted the « Battle of Anghiari »

on one of the walls of the Sala del Consiglio Maggiore in Florence. Possibly he used the same medium as in the «Last Supper», for his battle picture was also thought to be painted in oil. Vasari, indeed, tells us that «being desirous of experimenting with oil colours applied to a wall surface he mixed up a very thick composition for sizing the wall as a preparatory measure, but as soon as he began to paint on it in the Sala it trickled down the wall, causing him after a little while to give up the experiment as all his work was spoilt».

Bramante, on the other hand, was perfectly acquainted with the technique of fresco painting, as were the older Lombard masters. We know that he worked in this medium in Milan, Bergamo and Rome, painting on façades and in halls large decorative frescoes in which figures and architectural motifs are combined in splendid settings of perspective. A magnificent example of this still exists in the remains of the frescoes of the Casa Panigarola which were removed to the Brera in 1901. They show a marked affinity with the work of Piero della Francesca, and still more with that of Melozzo da Forlì; an affinity which is the less surprising when we remember that Bramante was nearly thirty years of age when he came from the Marches and that works by both these distinguished artists were within his reach before he left, and would thus have enabled him to develop an admiration of their monumental character and that precise knowledge of perspective which he himself also acquired and which ultimately led him to the study of architecture.

Bartolomeo Suardi studied first under Butinone, but went later (as did Cesare da Reggio who decorated the Sacristy in San Giovanni at Sarona) to Milan with Bramante, and so identified himself with this artist that he acquired the sobriquet of «Bramantino». He was born somewhere about 1470, and flourished at a period so prolific of great masters and of artistic development that he lived to see an almost complete change of ideals and methods. This man, whose prentice hand was guided by the gloomy and melancholy Butinone, was still living in 1536, when Michelangelo and Titian were approaching old age and death had already claimed Giorgione, Bramante, Leonardo, Raphael and Correggio. Radiant and refreshing, he had an equal

13

share with Leonardo in shaping the work of Agostino da Lodi, better-known under the nickname of «Pseudo-Boccaccino»; and prepared the way for Luini as well as for Gaudenzio Ferrari. His manner so closely resembles that of Luini that it is difficult to attribute some frescoes either to the one or to the ther. To quote an example, there are some who aver and others who deny that he had a hand in the execution of certain frescoes which formed part of the decoration of the Villa della Pelucca near Monza but were cut from the walls about a century ago and scattered, some going to London, Paris and Chantilly and the major portion to the Brera. A number of lunettes containing *putti* have been attributed to him, and it is therefore argued that he actually began the decorations and that they were continued and finished by Luini. This uncertainty is shared by a number of art critics whose reputations are of equal greatness, and shows at least that there is a remarkable similarity between the work of Bramantino in his maturer years and Luini in his youth; while it confirms the belief that the one drew inspiration from the other. It is true that the work of Leonardo was not long in influencing that of Luini; but it was what we may call an external influence, confined to certain details such as the management of the hair of his angels, and the usual smiling lips.

The principal characteristic which raises Luini (1485?-1532) above his purely Leonardesque contemporaries is the vastness of his pictorial compositions, to which is sometimes added a lively sense of grace, gentleness and poetry. The many pictures he painted and his great frescoes in the Villa della Pelucca near Monza; the work he did in Milan in Santa Maria in Vetere, in Casa Rabbia, in Santa Maria della Pace, in Santa Marta, in San Maurizio and in the choir of the adjoining convent; in Santa Maria degli Angeli at Lugano; in the Sanctuary at Saronno and his works in many other places, all bear witness to his fertility of invention and his speed of execution — two virtues which were certainly not common to the followers of Leonardo, and were not, if we may say so, shared by the great master himself. Unfortunately the variety of his subjects is not commensurate with the number of his compositions, and this may be the reason why his work is apt to appear monotonous. Nearly all his

heads appear to be copied from a single original, and exhibit the same resemblances that one would expect to find in the offspring of the same father and mother. A perfectly oval face; a broad, smooth forehead; a long, straight and regular nose; eyes somewhat far apart; a mouth usually just a little open and curving upwards at the corners; a rounded chin innocent of dimples; clear complexion of a «rosy pallor», turning sometimes to a deeper and more animated redness — such is Luini's accustomed type. In his hands it ceases to be the portrayal of a living being and becomes laboured and conventional. You may see it in his Virgin as well as in his Herodias and his Venus. It seems a strange thing to say, but there are pictures of his in which the same face appears several times over, beardless where it is a woman's or an angel's and adorned with a flaxen or light brown beard when it is the head of a saint or of the Christ. He was not even always able to vary his type when his subjects happened to be advanced in years, and neither his St. Elizabeth nor his St. Joseph invariably show the many summers that lie behind them. The complexion of the former has still the freshness of youth and her lips curve in the unvarying, machine-made smile; the white beard of the latter looks as though it were false.

Moreover, the student of art will detect a certain something of stiffness in all his figures, even where the subject would seem to demand free and passionate movement.

But what infinite variety Raphael imparted to the heads in his frescoes! What intense vitality there is in Correggio's figures! Yet both were contemporary with Luini; and for that reason, although it must be admitted that he has his exalted moments, we are unable to number him among the greatest of Italian artists or to agree that «he came so near to rivalling those supreme artists Leonardo and Sanzio that his pictures might be attributed to either of them.» That might have been written as part of a reaction against an all too long and unmerited neglect of this artist, or at a time when art criticism concerned itself primarily with pleasing externals such as beauty of feature and harmony of colouring; but it would be out of place nowadays,

15

when critics search as it were into the very soul of each artist and compute their relative values. Nor could it have been penned by Vasari when, with his mind still dwelling on the mighty achievements of the Renaissance, he looked back at the dizzy heights art had scaled in the past. He gives us a portrait of Luini that is well nigh perfect. « A painter of great delicacy and beauty, as may be judged from many of his works... perfectly executed in fresco. He also used oil colours with much deftness. He was courteous in manner and kindly in all his actions, so that he thoroughly deserved the praise due to every artist whose courteous bearing shines alike in his work and in his mode of life and whose excellence ennobles his art ».

It must, however, be admitted that he was capable of a certain poetic emotion in addition to his graciousness and « courtesy ». The parched and mountainous landscape wherein the scene of his « Gathering of the Manna » is laid preserves a sense of profound solitude and mystery completely in accord with the nature of the locality, despite the various figures he has set in it. The successive waves breaking on an almost flat shore in the « Crossing of the Red Sea » is a novelty in landscape painting which proved to be full of suggestiveness to his pupils. His « Burial of St. Catherine by the Angels » is famous for its poetry and delicacy. When the daughter of King Costus was beheaded (milk flowing from the wound in place of blood) the angels took possession of the body and carried it up to Mount Sinai in order that it might be interred in holy ground. In Luini's picture every incident is depicted simply, but with profound artistry. The beautiful features of the saint are marked by that nobility and austerity we should expect to find in a princess who was learned as well as royal. Twenty days of journeying with their precious burden have not wearied the celestial bearers: with tender and delicate gesture one of them carefully supports the fair, drooping head, while three other angels as solicitously hold the saintly corpse above the tomb before reverently lowering it to its final resting place. The perfectly horizontal line of the sarcophagus placed on the utmost summit of the mountain and against a dawning sky, is in harmony with that of the body; while the three angels bend

very slightly forward, the whole composition reminding us of the arched tombs so much venerated in the sanctity of the catacombs.

Bernardo Luini left neither a school nor scholars. The many who worked with him in his great frescoes betook themselves along other paths. It is easy to understand why. If every now and then some spark of his peculiar genius seems to flash forth in the work of artists near him in time and place it is open to question whether such manifestations were not really reflections from the looking-glass held up by Bramante and Bramantino.

<p style="text-align:center">★</p>

IT WAS a stroke of good fortune for painting in Lombardy that two artists of eminence, Sodoma and Gaudenzio Ferrari, should in the meanwhile have taken up their abode in Milan. Both came from Piedmont. The reason for their advent lay on the one hand in the ever increasing renown of Leonardo and on the other in a recognition of the fact that not one of the various groups of Piedmontese painters seemed likely to rise to eminence.

The history of painting in Piedmont scarcely begins until the second half of the fifteenth century. It is a common-place and uninspiring history of artists now influenced by the Tuscan school, now by the Lombard or Flemish and now by the French school; a history in which no group can be pointed out as possessing traditions of its own, with the possible exception of the short-lived and unsettled school of Vercelli. The great majority of the Piedmontese artists of this period had been born during the fifteenth century but lived far on into the following one. They appear, however, to have been much more tardy in adopting the «modern manner» than were the old painters of Lombardy and Emilia.

It is unnecessary to go over the earlier history of painting in Piedmont, crowded as it is with names and yet so unproductive of works of merit. Gian Martino Spanzotti, who was a septuagenarian when he died some time after 1524, is a figure of some interest, not so much on his own account but because he was the master who taught Defendente de Ferrari, Girolamo Gio-

venone and, above all, Sodoma. Spanzotti painted a number of pictures, and a vast series of frescoes in the ex-monastery of San Bernardino near Ivrea is attributed to him, in which we recognise a certain ability in portraying beauty and sentiment, not unmixed with faulty design and execution. Defendente painted an extraordinary number of pictures, perhaps as many as a hundred! They show a delicate technique and a feeling for expression. His figures are derived from a variety of sources. The artists of Lombardy, central Italy and even foreign countries such as Flanders, France and Germany, were laid under tribute as well as painters nearer home — Eusebio de Ferrari, Spanzotti and Macrino d'Alba. From all these he managed to evolve a manner which distinguishes him from his fellows, a manner resulting from a cold calculation of effects which were often more ornamental than decorative. Although he was still at work in 1535 his manner remains linear and symmetrical, particularly when his work is compared with what had been, and was being done elsewhere; and he gives a false impression of progress — or thinks to do so — by crowding his pictures with rich and minute details. And this at a period when contemporary art was jettisoning externals such as hangings and finery, and was striving after a perfect means of portraying forms and human expression. It explains in part why the name of this artist has so long been hidden in obscurity, and the consequent uncertainty and varied attributions regarding his work. He did not merit oblivion, and it is well that the veil has been lifted. The circumstances are, however, easily understood.

We would not go so far as to say the works of Chivasso, an extremely productive artist, are neither graceful nor pleasing. In common with the works of Girolamo Giovenone (1490-1555) they are not very interesting although restful and polished, and — after he had come under the influence of Gaudenzio — spacious and unfettered. Originality and novelty in an artist's work — not mere prettiness — make it notable. Art, in common with science, and, indeed, equally in common with every other branch of human endeavour, must be progressive. A scientist does not become pre-eminent by the simple process of mastering all that has been said or written about his particular

subject, any more than a musician becomes a composer as soon as he has acquired a complete knowledge of counterpoint. And a painter who wishes to become an artist must do something more than collect the recipes of his predecessors and contemporaries. Science, music, art; each of these may become a creative force, or may be taken up as a profession, or merely as a trade. There are painters whose work is without blemish and whose colouring is full of delicacy: yet history does not so much as record their names. As Vasari says, « they did nothing to advance their art and conferred no benefit on mankind ». Other painters there are whose work is not always faultless, yet their defects are atoned for by the illuminating power of an internal fire which radiates light instead of absorbing it. There are a great many people at the present day who know more about counterpoint than Rossini, Bellini or Verdi did, but none, or very few of them can express themselves in music with equal power or originality. There is a eulogy written in praise of the painter Gaspare Landi of Piacenza in which it is said that he was a better draughtsman than Correggio. That does not make any difference to the fact that Correggio was by far the greater artist. Woe to all who, as is so often the case, mistake mere prettiness for true beauty of form and especially of feature! To such Francia must be a better artist than Mantegna and Maratti greater than Rembrandt.

It is easy to understand that a local writer or the compiler of a catalogue would be likely to include every painter, great or small, who belonged to a certain region or city, if only for the purpose of making his information as complete as possible. We do not agree, however, that all of them were worthy to be mentioned in a general history of art. History is not a chronicle of trivialities but an account and a study of larger events and of the doings and sufferings of mankind. The history of science is a history of its discoveries, and it should be the same with a history of art.

And so it is not necessary here to describe the life and works of Giovanni Mazzone, Granmorseo, Ottaviano Cane, Gandolfino or, not to make this list too long, of the renowned Macrino d'Alba, a characterless painter who

19

departed from Piedmontese traditions and was attracted to the Umbrians and Tuscans who were working together in the Sistine Chapel (Perugino, Pintoricchio, Signorelli, Botticelli and Ghirlandaio) and who remained faithful to them to the end.

<div align="center">★</div>

LET us turn instead to Giovanni Antonio Bazzi, called « Sodoma », whose art has been the subject of many changes of opinion and of singular alternations of praise and blame. The chief cause for this lies in the inequality of his work; for while some of his paintings are accurate, beautiful and full of deep thought, others are superficial, careless and ugly. These are the outward expression of an extremely unusual personality and prevent us from praising his work unconditionally. Vasari gives us a somewhat fantastic portrait of him which is nevertheless not very far from the truth. He calls him a madman and a beast; and there is documentary evidence to show that the monks of Monte Oliveto used to call him « the arch-fool ». We are told that he was not in the least perturbed by the outrageous nickname of « Sodoma » bestowed upon him: « On the contrary, he gloried in it and wrote verses and ballads on the subject which he was in the habit of singing extremely well to the accompaniment of a lute ». We find, moreover, in looking through his letters and contracts, at least one in which he signed himself *Sodoma, Sodoma, derivatum mihi Sodoma*. He says that he keeps a great variety of animals, among them a raven that has been taught to speak. In one of his inventories this is confirmed: « I have at present eight horses; they are known as goats... a monkey and a talking raven. The latter teaches theology to a religiously-minded donkey I keep in a cage. Then I have a screech-owl for frightening away mad folk; another owl; two peacocks, two dogs, two cats, a hawk, a falcon, six hens and eighteen chicks, two Moorish cocks and a number of other birds which cannot be described without leading to confusion ». He concludes, « and I have three particularly evil beasts, that is to say, three women ».

Vasari tells us that the painter kept horses in order to enter for the Pallio

and other races held on solemn occasions, and we find them recorded as *currentes per festum Sancti Ambrosii* several years in succession.

To return to our more immediate subject, however, it should be mentioned that Vasari tells us how Sodoma included his own portrait in a fresco at Monteoliveto Maggiore, wearing a rich suit belonging to «a Milanese gentleman» who had gone there with the intention of becoming a monk. Now we read in the *Libro di Amministrazione,* or account book, of the monastery that on 5th May, 1505, the painter was given «a cloak, a doublet of velvet, a hood of black velvet, a pair of stockings of a pale violet, a black cap, a hat with a silken band, a horseman's cloak of felt — that is to say, an outer coat — a pair of velvet shoes, a sword and two embroidered shirts, the property of Fra Giovanni Ambrogio, one of our Brothers».

It is therefore clear that Vasari obtained his information with regard to the portait of Sodoma in Siena, where we find him in 1561, scarcely a dozen years after the painter's death. In the present instance it may be true the Aretine biographer laid on his colours, as it were, a little generously, but he did not invent the story itself.

We have our own reasons for going somewhat intimately into the character of Sodoma. Such a study will assuredly supply the key to his uneven and disordered work in which periods of disciplined correctness alternated with outbursts of carelessness and confusion. It will also help us to understand why certain writers have treated him with so much suspicion. It must be conceded that Sodoma is more inconstant and unequal than any other great painter; at the same time, if the critics were themselves to be judged according to their shortcomings they would scarcely continue to enjoy their present reputation. A writer who sets out in search of ideal perfection and fails to keep constant watch over himself is apt to be misled into assessing the value of a work of art more or less according to the dictates of temperament without perhaps appreciating that the true worth of an artist is to be judged from his best work and not from work which fails to reach so high a standard. If we adopt this as the basis of our judgment we shall inevitably recognise in

21

Sodoma a great artist. Even Vasari, who was one of his bitterest detractors, was obliged most unwillingly to voice his praise and admiration.

How can we deny that Sodoma's character was straightforward and honest, that his colouring was vigorous and fresh, his figures animated, his light and shade full of power, his types noble and beautiful? Or that he was fertile in invention and possessed in the highest degree a spontaneous and poetical sense of pictorial values? Who will deny that he set the art of the Sienese once more on the path of progress, waking it from a slumber which, though doubt-less sweet, held it immobile and made it as a thing apart, unconscious of the urge and revivifying power of «modern» art?

But we may arrive at a fuller understanding of his character by examining the theories which have been put forward concerning his early training. He was born in 1477 and when scarcely thirteen years of age entered the studio of Mar-tino Spanzotti, a painter whose whole outlook was bounded by the tradi-tions of the fifteenth century. Here Sodoma remained for seven long years. On the death of his father, a cobbler, in 1497, he left Spanzotti. In 1501 he was taken to Siena by the agents of the Spannachi, and from then till the day he died Siena became and remained his home. What was he doing during the four years which separate these two dates? Some think he joined Leonardo, but we may dismiss this theory at once. We cannot, however, quite so easily exclude the possibility of his having gone from Vercelli to Lombardy and Milan, for the influence of Lombard elements on his work is self-evident. We are aware that doubt has also been thrown on this supposition, but the doubt is based on no reasonable evidence, and arises only out of a desire to prove the impossibility of his ever having come directly under Leonardo's influence. It cannot be said with certainty that he never saw any picture by Leonardo or his followers; on the contrary, Vasari tells us that Sodoma acquired his «vivid colouring» in Lombardy before going to Siena. If so, it was from Lombardy that he brought his joyous army of vivacious and exulting *putti*. Correggio alone could rival him in his passion for these tiny, sunny crea-tures. The children who cluster so hungrily about the figure of Charity, or so-

lemnly hold a baldacchino over the Madonna, or mischievously crowd about the nuptial bed of Alexander and Roxana and are so eager to help the latter to disrobe, or sport with weapons in imitation of the devout gestures of Sant' Ansano or the warlike attitudes of San Vittorio, or swarm over his buildings to peep through the balustrades and lean far out over the cornices and climb up the arches — all these children he brought from Lombardy. The children of Tuscan art were few; they were well brought up, austere. They were incapable of indulging in games and dances and practical jokes, for in the art of Tuscany there echoed still the words of Girolamo Savonarola and the memory of his martyrdom was yet fresh in the minds of men.

And how is it possible to deny the influence of Leonardo on the « St. John the Evangelist» in the altar-piece at Turin and on the «Flagellation» now in the Accademia at Siena? Or the influence of Andrea Solario on the « St. Jerome » of the Mond Collection in London? Are not the grim visages of some of his old men at Monteoliveto, the vigorous employment of light and shade and the smiling lips to be attributed to the influence of Leonardo? And are not his landscape backgrounds and the decorative pageantry of his architecture traceable to a Lombard source?

It is of course true that such influences would be tempered by the personality of the artist himself and modified by other influences encountered in the land of his adoption; and it would therefore be unwise to assume that Sodoma did not take up his residence in Milan between 1497 and 1501. Siena, in the geographical centre of Italy, is central also in the matter of art. It lies between Tuscany, Umbria and Latium, and its very position made it impossible for it during the earlier part of the sixteenth to resist the attacks delivered from all sides upon its naively backward methods. It is not very surprising, therefore, if in certain frescoes by Sodoma — especially in his earlier ones at Sant' Anna in Camprena near Pienza, and at Monteoliveto Maggiore (that is to say, the work done between 1503 and 1507) — we detect traces of Umbrian influence in the arrangement of the figures and sometimes in their mien, and in certain faces which he has foreshortened after the man-

ner of Perugino. These Umbrian tendencies were but fleeting, and it would be wrong to attribute them to the influence of Pintoricchio rather than to that of the Umbrian school in general. To imagine, for instance, that the background in the fresco of «Guido Tarlati, Bishop of Arezzo, approving the ordinances of the Olivetan Order drawn up by the Blessed Bernardo Tolomei, founder of the monastery», is copied from one of the frescoes in the Libreria Piccolomini would be an extremely serious error chronologically. The truth is that Sodoma's work at Sant'Anna in Camprena was finished two years before Pintoricchio, in 1505, began his frescoes on the walls of the Libreria. As a matter of fact, a background of similar type had been adopted by Melozzo da Forlì a quarter of a century earlier in his fresco of Platina. More remarkable still, we find the same background in some drawings by Bramantino, the truth being that the motif here adopted is the characteristically Lombard one of a high balustrade with circular balusters interspersed with *putti*. Moreover, so progressive and lively an individual as the sensual Sodoma would not be likely to have much sympathy with the orderly and devout Umbrians. It was little enough he acquired from the example of Signorelli; their differences in character and artistic disposition were too great. Signorelli was hard and austere; Sodoma gay and gentle. When he pays his two visits to Rome — the first before 1507 in order to decorate one of the halls in the Vatican, and the second in 1510 to perform a similar task in Agostino Chigi's Palazzina, better known today as the «Farnesina», — we see him casting aside every vestige of fifteenth century tradition; and if at the last return to Siena his work is faintly tinged by contact with Raphael — as for instance, in the angels over the fresco of the «Beheading» in San Domenico at Siena — it is still a complete and felicitous expression of his own personality.

His first work in Rome, the pictures in the Sala della Segnatura, was never completed. We may believe Vasari when he says that «he began by decorating the vault with cornices, friezes and foliage, and then filled a number of circular panels with various subjects, all done in fresco and well executed. But, brute as he was, he devoted more time to his bestial habits and amuse-

ments than to his work, so that when Bramante brought Raphael of Urbino to Rome His Holiness, knowing how greatly this artist excelled all others in merit... gave orders that Giovanni Antonio was to discontinue his frescoes... indeed, that all he had done was to be destroyed. But Raphael, who was goodness and modesty personified... only removed the filling and the figures in the circles and panels, leaving the friezes and other decorative portions which had been done by the « Arch-fool » intact so that they now enclose the figures painted by Raphael ».

The very beautiful arrangement of the panels (traditional, it may be, but unusually graceful and charming), the central octagon with its *putti* and the eight polygons between the circles are all of them the work of Sodoma.

He returned to Rome at the summons of Chigi to paint the frescoes in the Farnesina, imparting singular grace to his figures and more particularly to those in the « Marriage of Alexander and Roxana »; grace which is Apollo-like in the male figures to the right but becomes somewhat mawkish in the women to the left, though rising to a rare degree of excellence in Roxana herself. Her exquisite beauty is tempered with maidenly modesty and reserve, and her face is suffused by a graceful pensiveness in which love, desire, timidity and hesitation each plays its part. It is a thousand pities that this superb example of pictorial and poetic art has escaped the attention of certain critics, especially as we find this same quality expressed in a slightly different form, notably in the two groups of the « Ecstasy » and the « Trance of St. Catherine ». It is to be seen, too, in some of the figures in the « Beheading of Niccolò Tuldo », as well as in the famous « St. Sebastian » in the Uffizi.

In the « Ecstasy » St. Catherine is represented as wholly absorbed in contemplation of the Virgin; her lips parted, her hands raised in a gesture of surprise. Two companions stand by, watching with loving eyes. When she swoons both hurry to her assistance. One bends over her while the other endeavours to raise her.

In the fresco of the «Beheading» St. Catherine kneels to the left of the picture, her hands joined, her tear-filled eyes raised to Heaven. Her tremulous lips move

in prayer, seeming positively to quiver with emotion. The fervour depicted on her emaciated face and the attenuation of her body half persuade us that she might be sister to Giacomo Cozzarelli's Magdalen.

In the Uffizi « St. Sebastian » no sense of chastity is violated by the supreme beauty of the martyr's body. Above all, it is not allowed to distract our attention from the profoundly poetic suggestiveness with which the shadow of a hovering angel falls athwart the face of the saint, resting on his forehead like a veil of purity as though it were the outward visible sign of inward fervour.

But if at this point we were to be asked if Sodoma is to be numbered among our greatest artists such as, for instance, Michelangelo, Raphael, Correggio or Titian, our answer would be in the negative. We are not taking into consideration his lapses into carelessness or, above all, his irresolution. Even the great painters we have named had similar moments of weakness, though in a lesser degree. Sodoma fails to reach the supreme pinnacle of art by reason of certain fundamental defects in his artistic make-up; that is to say, certain faults not of momentary occurrence but permanent, and increasing rather than otherwise with the passing of the years.

Admirable as a painter of isolated figures or of small groups, he is bewildered when dealing with large compositions. He crowds his figures, forces them into position, heaps them up; he over-fills every space and scatters pompous details everywhere with too generous a hand. Why are the « Ecstasy » and the « Trance of St. Catherine » set in common-place scenes sprinkled with Roman monuments and pilasters adorned with pretentious, multi-coloured candelabra? With cherubs roosting on the cornices like so many chicken? Why, much to the detriment of his perspective, has he inserted those great figures at the top, unless it be to fill the whole of the sky as well? How much he might have enhanced the pictorial and romantic value of his subject by setting it against the silent, tranquil background of an anchorite's cell!

His colouring, too, which in his single figures is lustrous, vivid and joyous, is combined with perfect modelling produced by the melting of high lights into shadows, but it appears almost devoid of aerial perspective, so that the

26

clumsiness of his compositions is aggravated by an absence of atmosphere.

These are the wood-mites sapping the base of the ladder by which he might have risen to the heights. He was a magnificent figure painter, but he lacked the power of handling large groups and was unable to surround his figures with a proper feeling of atmospheric space.

<p style="text-align:center">★</p>

GAUDENZIO FERRARI was undoubtedly a greater painter than Sodoma, but he, too, lacked some of the qualities which would have placed him among the greatest artists. He is comparable with Sodoma and Luini, but his fertility of invention and skill in composition were greater than Sodoma's, while his types were more varied, his dramatic power more pronounced, than that of Luini.

He was born at Valduggia in Valsesio somewhere about the year 1471 and learnt the rudiments of art in his native district. Then he went to Vercelli. There for some years he had his own workshop, in which Bernardino Lanino, Giuseppe Giovenone and others received their artistic training. It was not long, however, before all trace of his Piedmontese apprenticeship was oblit-erated by the influence of the Lombard masters. We recognise the inspiration of Bramantino in the clarity of his colouring and his practice of illuminating his figures from below in a way that almost suggests stage footlights: in his architectural backgrounds we recognise the influence of Bramante, and in his landscapes executed with tiny, pen-like brush strokes the influence of the Lom-bard school in general.

In days gone by credence used to be given to the statement first made by Federico Zuccari and repeated later by Baldinucci and others to the effect that he was « one of the most brilliant scholars ever trained in the school of Pietro Perugino », and that he worked with Raphael on some of his pictures. Did this report grow out of the circumstance that in some of Gaudenzio's work — for example, the many-panelled picture painted in 1511 at Arona — there is a hint of Perugino? The traces of Umbrian influence in his work are fleet-ing and very slight, but they are undoubtedly derived from Perugino. Still,

he could have studied the art of this master without setting foot outside Lombardy, for in addition to a few small easel pictures there was at Cremona an altar-piece painted by him in 1494 in the church of Sant'Agostino and another which only five years later was placed in the Certosa at Pavia.

In any case it is impossible to deny that even in some of Gaudenzio's principal works there are certain traces of fifteenth century methods, as, for instance, in the frescoes at Santa Maria delle Grazie at Varallo and in the Sanctuary at Saronno, in both of which he has adopted the time-honoured device of throwing certain portions into relief by the employment of modelled and gilded stucco. Furthermore, as Lanzi acutely observes, the cupola at Saronno « is peopled with figures which, although beautiful, varied and well posed, are, in common with those in other works by this artist, nevertheless not entirely free of every vestige of archaism, such as over-symmetrical and formal grouping of the figures and a suggestion of Mantegna in the drapery of some of the angels ». Equally reminiscent of the fifteenth century is the great profusion of decorative adjuncts modelled on the fashion of the day we find in his pictures, a practice to which neither Leonardo, nor Michelangelo nor Raphael nor Correggio, nor even Titian, would have had recourse, albeit they were so much affected by the Vivarini, by Crivelli and by Carpaccio. There are golden nets on the heads of Gaudenzio's Madonnas and their raiment is splendid both in hue and material. The women in his « Nativity » wear hair-pads and turbans, while even in his « Crucifixion » there are officers and soldiers with polychromatic striped stockings and huge bunches of feathers in their helmets; to say nothing of angels holding sumptuously bound and heavily embossed books and an indescribable variety of musical instruments.

All this of course adds richness, interest and vitality to Gaudenzio's work, but it is a richness, an interest and a vitality that would have been scorned by the giants of the sixteenth century.

Nor must we ignore the fact that Gaudenzio sometimes transgresses by stifling his figures with too great an abundance of clothing, giving them an appearence of deformity and attitudes which are somewhat coarse, as any one

may see who cares to examine his work in the Cathedral at Novara, the «Flight into Egypt» in the Cathedral at Como or the «Assumption of the Virgin» in San Cristoforo at Vercelli.

But with these exceptions how vigorous, how fertile, how magnificent he was as a painter! How infinite his variety and originality of thought, his psychological penetration, his delicacy of touch! How facile he was with his brush! In addition to his great frescoes at Varallo where, among other things he painted in 1513 twenty-one episodes from the «Life of Christ» on a wall-surface more than eighty metres square; in addition to his frescoes in San Cristoforo at Vercelli, where there are some exquisite scenes from the «Life of Mary and of the Magdalen» and a great, many-peopled «Crucifixion»; in addition to the cupola at Saronno, where he painted the «Angelic Concert» in 1534-1536; in addition to minor frescoes and some works that have disappeared — in addition to all these he painted no less than fifty other pictures, many of them large altar-pieces consisting of several panels. The one of «San Gaudenzio» in the church of that name at Novara, the «St. Mary» at Arona and the «San Gaudenzio» at Varallo may be mentioned as examples.

Even where his compositions savour of the older tradition, as in the arrangement of his angels in concentric rings in the cupola at Saronno, he contrives to impart endless variety of attitude to his figures, infinite change of facial expression and bodily gesture. There is lightning in his high lights and witchcraft in his colouring. The whole work is a triumphant infusion of new life into an old artifice of perspective. The result is perhaps a little theatrical, but it is vigorous and full of fascination. It is natural that the treatment of a vast chorus of beautiful angels, all of them singing from sheets of music and supported by an orchestra of other angels — the latter even more closely packed together, equally beautiful and playing on the richest and most varied musical instruments — should make a particular appeal to this magnificently minded painter. Music was his especial delight, and Lomazzo by way of supporting this statement tells us that he was «a performer on the lyre and on the lute».

But by far the best evidence of Gaudenzio's excellence is, in our opinion,

to be seen at Vercelli, especially in the cycle of scenes from the « Life of the Magdalen ». In the episode of her arrival at Marseilles we have an epitome of his highest qualities as a painter, from the freshness of execution — so full of « modernity » — to that delicacy of expression which makes us agree heartily with the writer who said of him that he « portrayed souls » The attitudes of the figures is free from exaggeration, and although richness is not absent from the draperies it is toned down by severe colouring. Furthermore, the value of the work is increased by the beauty of certain of the portraits, to which the sensitiveness of the artist rather than the requirements of his subject has imparted nobility and loftiness without in the least affecting their interest as studies of character. In the landscape there is nothing fantastic: to the right there are unobtrusive architectural features, while the gateway on the left is surmounted by a building, with towers and rocks fading gently into the haze, « producing an effect of vast spaces ».

The fresco is in two parts. In the lower half we see St. Mary Magdalen disembarking, having been placed by the infidels in a boat without a steersman. With her are her brother Lazarus, her sister Martha, Martilla the maid-servant of Martha, the Blessed Cedonius (the blind man whose sight was restored by Our Lord) and St. Maximinus. Pushed out from the shore in the hope that its occupants might perish, the boat drifts instead towards Marseilles and arrives with all on board before the portal of the pagan temple. Here the Magdalen and her companions preach the religion of the one True God to the populace and to the Prince of Marseilles, who hurries to the spot accompanied by his wife. In the upper half we see them all returning from a journey in search of St. Peter, having suffered great dangers by the way. Full of devout meditation they kneel with bowed heads before St. Maximinus, who baptises them. The Magdalen, standing at the right hand of the saint, bends over them in rapt attention, while other figures stand by deeply moved. An admirable picture, both as a work of art and of « religious majesty ».

Vasari did not understand Gaudenzio as he ought to have done, and we feel certain that he never saw the greater works of this artist at Varallo, Sa-

ronno and Vercelli. He does not give us an account of his life, and the few words dedicated to him are niggardly in the matter of praise. He tells us that he was considered a man of merit « while he lived », that he painted figures « with strange postures » in Santa Maria delle Grazie at Milan and says that he competed unsuccessfully « with Titian in a picture ». Lomazzo praises him. « Painter, modeller, architect, student of nature, poet, musician... nature in him was so apt and so fertile that his works appear to have been done without the assistance of art ». He adds that « his interpretation of divine things and the mysteries of our faith was admirable », portraying « the motives of religious majesty, prudence, temperance, piety, justice, grace, faith, equity and clemency ». Lanzi was more moderate, but recognised powers of technique and expression in his work. Then his fame began to decline. When Roberto d'Azeglio in 1832 had the courage to acclaim him as a « great genius » and « among the most talented men who ever adorned Italian art » his words were regarded merely as the expression of a staunch partisanhip for a local celebrity. In process of time, however, a just valuation of his merits began to make steady headway; and he is now considered to have been the greatest of all the artists who were born and flourished between the Alps, the Adda and the Po.

Girolamo Giovenone is the chief Vercellese representative of his school and manner, and acquired a certain breadth of form without, however, detaching himself from fifteenth century models. More able, and more faithful to Gaudenzio was Bernardino Lanino. He was of a joyous and happy disposition but, as in the case of so many others, his work in time became hackneyed. He became wedded to certain types and poses, and weak in his treatment of light and shade, while the pallor of his colouring increased to such an extent as sometimes to appear livid. Taken as a whole, his work appears to be that of a delicate and elegant painter, but devoid of any creative force and therefore of little significance in the history of art and of little service in maintaining the vitality of the school. The school of Vercelli, in fact, ceased to exist as soon as it had squandered the legacy bequeathed to it by Gaudenzio.

31

LANINO died at the age of about seventy in 1583, having worked not only in his native town of Vercelli but in Novara and in Milan as well. When the school of Leonardo came to an end the great Lombard metropolis became dependent for its adornment on the work of the artists who flocked to it from the surrounding districts. There were no longer any Milanese of outstanding ability at work in the city unless we except Giovan Paolo Lomazzo, the son of a sister of Gaudenzio and born in 1538, and a pupil, Ambrogio Giovanni Figino, who was ten years younger. Lomazzo was a painter with a mannerism, but cultured and earnest; a « seeker after novelties ». His career, however, was early cut short as he became blind at thirty. He lived to be nearly double that age and devoted himself to poetry and the writing of fantastic books, such as his « Trattato dell'Arte della Pittura » (1584) and « L'Idea del Tempio della Pittura » (1590), in which notes and observations of interest are drowned in a flood of verbosity and whimsicalities. Figino worked for a longer period, but his only achievements of any note are a few portraits; that, for example, of Lucio Foppa, Commander of the Forces, commissioned and largely paid for by the Milanese Senate.

Gaudenzio and Lanino came to Milan from Piedmont, and Nicola d'Appiano from Como. The last was painting in the Cathedral between 1511 and 1541. Others came from Lodi and from Cremona, a city rich in painters.

The Piazza family of Lodi produced a number of artists, but only three of them are remembered today. Two were brothers: — Albertino, who died in 1529, and Martino. Their artistic training had begun under the influence of Bergognone, but they turned later to the example of Leonardo (as interpreted, perhaps, by Cesare da Sesto) and later again to the methods of Raphael. The third of the trio was Calisto, who was working until about 1562 and inclined towards the example of Romanino and Pordenone. But how difficult it is to distinguish and to classify these masters, so ready to bow to every artistic breeze! Calisto alone emerges as a tangible individual who signs and dates his pictures. His work is joyous both in gesture and colouring.

The fifteenth century had already seen the formation at Cremona of large

and prosperous groups of painters, although there is nothing to indicate with certainty that there were any artists residing in the city who remained faithful to Lombard tradition or to the schools of Verona and Venice. It was not their habit to reside perpetually within the city walls but to wander from place to place in the lower valley of the Po, adorning churches and castles. Little by little these painters, naturally enough, became weaned from the rigid formality of the fifteenth century and developed a more « modern » tendency, but it was a change that came about with provincial slowness. It is, indeed, interesting to observe that the transformation of Cremonese art was not the result of the example set by Gaudenzio but was brought about by artists under Venetian influence: by Romanino and Pordenone and above all by the powerful genius of Correggio, which, as we shall see, endured beyond his age and extended beyond the Alps.

The Cremonese painters of the early sixteenth century, such as Tomaso Aleni, called Fadino, and Francesco Casella (both of whom lived until about 1525) and Altobello Ferrari, called Il Melone — the last an adequate draughtsman but a harsh colourist — were incapable of throwing off the last fetters of rigid tradition. Not even Boccaccio Boccaccino, their contemporary, was able to do that, although his work is an advance on theirs and richer in character. He was born in 1467 and spent his youth in Ferrara with his father Antonio, an embroiderer by trade. In 1496 he was in Venice and in the following year in Genoa and Milan, being thrown into prison in the latter city. In 1499 he was back again in Ferrara, and while there killed his wife because of her adultery. He left his mark on painting in Ferrara, as may be seen in a number of pictures by Mazzolino and Garofalo. After further adventurous journeyings he took up his abode in Cremona in 1505 and died there before 1530; at a time, that is to say, when Italy, from Venice to Florence and from Parma to Rome, had witnessed the miracles of the new painting. He, however, had done little more than develop the models of Cima da Conegliano, Alvise Vivarini and, more particularly, of Bramantino. A certain breadth in composition, a certain elegance in the treatment of his draperies:

33

these things do not deceive us. In his heart he remained of the fifteenth century — pleasing enough for the nobility of his faces, softness of colour and for types that are specially notable for the mild astonishment reflected in their pale eyes. He had, however, a number of followers, from his son Camillo (1501-1546) and Pietro and Gian Francesco Bembo (both of whom died before 1530) to the whole brigade of the Campi and to Sojaro; although it was not long before all of them drifted away from his teaching, attracted by the «new order» which was making itself felt in the neighbourhood and even in the city itself. In the Cathedral at Cremona Romanino and Pordenone were in 1519-1520 painting great frescoes, and Dosso Dossi was putting up his «San Sebastiano» in the church of the Annunziata. The last named picture is now in the Brera.

Romanino went on from Cremona to Brescia — no very great distance — and there carried out a number of important works in his own energetic and vivacious manner: Pordenone travelled an even shorter road, going only as far as Cortemaggiore and Piacenza, where Raphael's incomparable masterpiece of beauty and idealism, the «Sistine Madonna», had made its appearance in 1517. Nor were the Cremonese any less attracted by the flame that had been kindled in Parma; while at Mantua, so easily reached by water from Cremona, Giulio Romano was busily engaged in building and decorating the Palazzo del Te. It is not in the least surprising that the artists who had grown up in the shadow of the Torrazzo at Cremona should warm their hands at fires which had so suddenly burst into flame but which they had themselves been incapable of kindling. Giulio Campi (1502-1572) the stoutest and most valiant of them all, followed first Romanino, then the Venetians, then Dosso and, finally, Giulio Romano. It must be admitted, though, that he did not merely copy; he assimilated with ease the lessons to be learnt from others. For that reason his work does not lack freshness, and he produced a respectable number of pictures which do him credit. His brother Antonio had not his qualities as a painter, but he made up for it by a versatility approaching that which Italians have always dreamed of as an ideal. He was

architect, sculptor, cosmographer, historian. In painting he followed his father, followed his brother, followed Correggio, followed Dosso, sometimes almost copying the work of the last-named, as is proved by a comparison of his Castelbarco «St. Sebastian» with the one by Dosso already mentioned.

The only other member of the Campi family requiring to be mentioned is that very busy person Bernardino (1522-1590), who grew up in the school of his uncle Giulio and then went over to that of Ippolito Costa in Mantua. Having studied Pippi's works he did not hesitate to copy them — as may be seen from the Prophets painted by him in San Sigismondo at Cremona in 1554. He afterwards changed his adherence and turned his eyes and attention to the work of Correggio, contriving to acquire something of his form but nothing of his spirit.

Bernardino Gatti (1495?-1575), known as Il Sojaro, acquired rather more of Correggio's spirit. His compositions are vivacious, even if they are not very profound. He was born in Pavia but worked for a long time in Cremona, where he painted many notable pictures representative of his art at all stages from youth to old age. His best work is considered to be his fresco in the cupola of the Madonna della Steccata at Parma, but unfortunately, owing to its too-close proximity to Correggio's domes, it is one in which it is difficult to estimate his qualities as an artist. This work also suffers by being coterminous with frescoes of extreme delicacy of drawing and technique executed by Parmigianino and Girolamo Mazzola Bedoli. One of Il Sojaro's pupils was Sofonisba Anguissola, born in 1531. Her sacred pictures are common-place but her portraits are pleasing and became so renowned that she was summoned to Spain as a portrait painter. There she was highly successful both as an artist and as a woman. She became the wife of Don Fabrizio di Moncada and lived with him in Sicily. On his death she set out for her native land and on the way accepted a second offer of marriage from the captain of the galley on which she was travelling. One of her most respectful admirers in her extreme old age was Van Dyck.

Finally, we must mention Gian Battista Trotti (1555-1619), nicknamed Il

Malosso. He was rapid and effective as a draughtsman but somewhat harsh as a colourist. He belonged first to the Campi school but later deserted it for that of Parma, and was employed in that city for many years as court painter to the Duke.

With Luini dead and Gaudenzio gone elsewhere, it was of a surety neither the children of the former nor the pupils of the latter, nor yet a handful of other second-rate artists, who maintained the prestige of painting in Milan.

Polidoro da Caravaggio was far away, and Cipriano Vallorsa (at work between 1540 and 1591) was nursing his sweet devotional dreams — reminiscent of the school and example of Fermo Stella, another follower of Caravaggio — in the solemn calm of the Valtellina. Milan had in the meanwhile come under the dominion of Spain, in every sense the worst possible type of ruler and devoid of every high ideal of culture. Accordingly not one of the more famous painters of the day took up his abode there or left there any great work of art. Instead of them came the Piazza from Lodi and all the tribe of Campi from Cremona.

Just outside the borders of the state artists of a totally different calibre were at work, but it seemed as though the gates of Milan were barred so far as they were concerned. Moretto, Savoldo, Romanino and Moroni were working at Bergamo and Brescia, inspired by the revivifying breath of Venice. Pordenone and Correggio rarely deserted the right bank of the Po, and it is there that the only two pictures sent by Raphael into Northern Italy are to be found. Nor did Piedmont or Liguria appear to offer any greater attraction or better fortune. We have already seen what was the position in Piedmont. Of Liguria it may be said that it produced but a single artist of real ability during the sixteenth century. That man was Luca Cambiaso (1527-1585), an artist who planned and executed his work with such rapidity that he was reputed ambidextrous. Anxious to learn all there was to know and to attempt whatever might be essayed by man, Cambiaso when of mature age went to Florence and Rome and elsewhere in order to study the work of the most celebrated heroes of the Renaissance. His drawings, of which there are many in all the

big collections, have been praised for their boldness and rapidity of execution, but in our opinion there is an abuse of hatching and an exaggeration in the foreshortening which deprives them of that feeling of sincerity which is the most desirable quality to be found in a drawing. Some of his paintings, on the other hand, are notable on account of their splendour of composition, the admirable distribution of light and shade, the excellence of his colouring and the expressive faces of his men and women. At one time his «Paradise» in the Escurial was greatly admired, but the tendency of modern criticism is to consider that its animation is due to a false emphasis obtained by drastic rather than merely vigorous methods. This characteristic of the work has been attributed to his state of mind, as at the time he was engaged upon it he was suffering from the effects of an unfortunate love affair.

If we were writing a history of painters instead of a history of painting we should at this point be compelled to break off and cover page after page with the names and particulars of an infinite number of artists who crop up in books and documents. A history of painting, however, need only concern itself with examining and defining the changes produced in it by the example of individual artists, by local condition and by the march of time. It certainly cannot be said that Pantaleo or Lazzaro Calvi, or Andrea Semini, or Valerio Corte, or many another, were bad painters; but there is nothing in the character or quality of their work which is of special significance with regard to the period or the locality in which it was done.

Genoa also had its own individual characteristics as a school of painting, but it is a seventeenth century school; and it vied, not with Piedmont or Milan—each of which had its artists of merit without having a particular school of its own — but with Bologna, Rome and Naples. It is, indeed, an interesting fact that while Bologna and Rome could each point with pride to a splendid artistic tradition, Genoa and Naples — that is to say, the two great Mediterranean cities — seemed only to awake at a later period and to show an aptitude which had been denied them in the past.

VERY differently indeed ran the river of art through the fortunate region included in that huge triangle whose confines are the Po, the Apennines and the sea, and at whose apex stands Piacenza, with Rimini and Ferrara to emphasise the angles at its base. With Tuscany and Venice it unquestionably represents the great triad of Italian art. In the thirteenth century this region was already embellishing itself with vast decorations in the Romanesque style; in the fourteenth it could boast of schools of repute at Parma, Modena, Bologna and, above all, at Rimini, whence issued excellent artists who wandered with their talents as far as the Marches on the one hand and to the Alpine castle of Collalto on the other. At about the same period Tomaso Barisini went from Modena to Treviso, taking with him the first throbbing impulses of a new realism, while his fellow townsman, Barnaba, transferred to Liguria his timid but noble artistic creations. Then came the fifteenth century. The Emilian schools of painting at first seemed weak and uncertain, torn between the retarding influence of habit and the desire for new forms. Suddenly there burst forth in Forlì Melozzo degli Ambrosi, whose knowledge of perspective was wedded to a rare degree of virile beauty, and in Ferrara a whole troop of artists who developed the pioneer work of Pisanello and Pier della Francesca into art forms of remarkable individuality and gave them an utterly distinctive and vigorous northern impress. Then there were Cosmè Tura, Francesco del Cossa, Ercole Roberti and, finally, Ercole Grandi and Lorenzo Costa. These last extended their sway to the capital of the Bentivogli, Bologna, where it engendered the school of Francesco Francia, a school which became more famous than all the others. It excels them not so much on account of merit as for an easily explained aesthetic reason. Ferrarese art is distinguished by a deep and searching realism which is sometimes harsh and even brutal. It was compelled to be so if it hoped to overcome and destroy the older traditions which, although losing ground, were by no means inclined to give way altogether. The battle the Ferrarese were fighting was therefore of a reactionary nature, and it was for that reason they disdained an opportunity which might have given beauty to their work — often desirable but equally often dangerous — and a

sentimentalism that was invariably dangerous. When the fight had been won this harshness in the work of the Ferrarese began to seem excessive: they desired peace and loved gentleness. Costa tried to work according to the new ideals, but it was Francia who succeeded in doing so. Those figures of his with dreamy eyes full of tranquil piety attracted general attention, and although not blessed with a wealth of ideas, he was bombarded with commissions and his workshop crowded with scholars who flocked to him not only from Emilia but from Romagna, the Marches, Lombardy and from places even further afield.

But, as we have already hinted, Francia suffered the misfortune that befel other artists of note, such, for example, as Carpaccio, Perugino and Bergognone. These men found themselves in the early years of the sixteenth century in the full flood of a modernised art and had not the power to follow the splendid path that led upwards. In addition to witnessing the condemnation of their work they were compelled to stand by while, one by one, their scholars deserted them. It was the voice of Venice that sang most sweetly in the ears of the Ferrarese: Bologna, Romagna and the northern part of Emilia preferred to listen to the voice of Rome.

Among the first who popularised the works of Raphael by means of the printing-press were Marcantonio Raimondi and Giulio Bonasone of Bologna, Marco Dente of Ravenna who was killed during the sack of Rome, and Enea Vico of Parma.

Two works of Sanzio were sufficient to evoke a new enthusiasm; the «St. Cecilia,» which arrived in Bologna in 1515, and the «Sistine Madonna,» which reached Piacenza two years later. We have already mentioned the anecdote or legend connecting the name of Francia with the arrival of the «St. Cecilia,» and we have already observed that even if the story is not true it is indicative of the position which had arisen.

There were many painters in Emilia, and more particularly in the Romagna, who were attracted by the new movement in art. Giulio Marchese (1471-1540) and Bartolomeo Ramenghi (1484-1542) known respectively as Coti-

39

gnola and Bagnacavallo from their birth-places; Biagio Pupini delle Lame (1490-1530) and Innocenzo Francucci of Imola (1494-1550) and others turned away from Francia to follow in the steps of Raphael. Ramenghi, however, was not above studying the works of Dosso Dossi as well, and adopted an exaggerated version of his colouring. In this he was more far-seeing than Francucci; for the latter, for all his pretentions to solemn dignity and accuracy, never rose to any distinction. His colouring is often harsh and crude, his flesh tints are the hue of terra cotta and he sets red draperies with yellow reflections in close proximity to draperies of the brightest green. While Raphael used contrasted colours Innocenzo abused them. He was, perhaps, the first of the artists who used such contrasts to excess, and whose work indicates a particular period in the history of Bolognese art.

The influence of Raphael on Ravenna was less marked, although it lingered longer in the work of Luca Longhi (1507-1580). In Faenza it lingered in the work of Giacomo Bertucci (1501?-1579), Giulio Tonducci (1513?-1583) and Marco Marchetti (died in 1588). The small pictures crowded with figures and the sparkling grotesques painted by the last-named were much admired and sought after both in Florence and Rome. In Forlì some of the work of Francesco Menzocchi (1502-1572) showed brief signs of Raphael's influence, but as a painter Menzocchi was irresolute and wavered between the methods of Palmezzano, Genga and Pordenone, passing from boldness to timidity of colouring coupled with a predominance of delicate alabastrine yellows. There were, too, other schools and artists who by remaining faithful to Raphael were indirectly instrumental in extending his influence. By Pierin del Vaga the Raphaelesque tradition was passed on to Livio Agresti, who died in 1580. Francucci transmitted it to Prospero Fontana (1512-1597), and to his daughter Lavinia (1552-1614) — a painstaking but pleasing portraitist — while Giulio Romano transmitted it to Francesco Primaticcio (1504-1570), his assistant in Mantua, who subsequently earned fame as a decorative artist by the work he did at Fontainebleau for Francois I and Henri II in partnership with Niccolò dell'Abate of Milan (1512-1571).

The work of these two artists and the more free and original work of the Florentine Rosso gave rise in France to a movement which may be regarded as the beginning there of classicism — not on any account to be confused with the neo-classic movement. It was a first step towards an understanding of Italy's culture and her love of ancient art; or, rather, towards an appreciation of physical beauty, grandiose treatment and the selection of subjects for portrayal. The people of France understood instinctively the high principles underlying the work that was being done by the so-called School of Fontainebleau and were held spell-bound by it, valuing the work itself more highly than its purely pictorial merit deserved. It is a mistake to regard Primaticcio and Niccolò dell'Abate as followers of Correggio. At the time when these two painters went to France (1531-1532) Correggio had acquired but a moderate reputation and his school was restricted, as we shall see, to a handful of pupils in Parma. Lodovico Ariosto, born in Reggio Emilia and thus his fellow countryman, does not even include him in his «Orlando Furioso,» as among the great painters of his day. But apart from this, it is a fact that the style of decoration adopted at Fontainebleau is that which we see in the Palazzo del Te, where under the guidance of Giulio Romano Primaticcio had studied and worked before he went to France.

For the rest, the art of the Raphaelites in Emilia was not really true art but a sort of academy. The art of Raphael, made up of a blend of Umbrian and Florentine teaching and raised to heroic proportions in the atmosphere of Rome, was something which the light hearted Emilians could not understand except as a kind of lesson to be learnt in school. The painters we have named, instead of endeavouring to explore the innermost recesses of his profound and melancholy idealism, were content to copy his faces, his figures, his draperies and his tints. We have but to wander through the churches of Bologna to find constant reminders of his «St. Cecilia». Even Bartolomeo Passarotti, of whom we shall have more to say later, paid homage to the celebrated painting by imitating parts of it in his «St. Ursula and the Virgins», while the figure of the saint was traced once more in Biagio Pupini's picture in the church of San

41

Giacomo, where it joined company with other Raphaelesque figures in the frescoes executed by Pellegrino Tibaldi in the Poggi chapel.

It became, in fact, a craze, a type and an inspiration that was not really consonant with the Emilian temperament, and the result was that there came an equally exaggerated reaction and a long and bitter controversy. Annibale Carracci, looking towards Correggio, spurned the work of Raphael and, writing of the figure of St. Paul in this very same picture, the «St. Cecilia,» says : — «I at first considered it miraculous, and now it seems to me to be a block of wood».

What Carracci was confessing in 1580 Dosso Dossi (1479-1542), the chief ornament of Ferrarese painting, had already felt when he remained faithful to the Venetian school. That he had been the pupil of Costa is not impossible; but it is very certain that he quickly tired of so timid a teaching in order to follow the clamorous example of Giorgione and Titian. Through him Ferrarese painting acquired new strength of colouring and, above all, of poetic expression which is extended to his landscapes and compositions as well as to his figures. On account of his imaginative ability, the heroic poses of his masculine figures, the soft and sensuous poses of his women and the mystery pervading his backgrounds he has been called, and rightly, the Ariosto of painting. This felicitous coupling of the two names is due to Vasari. «At about the time that it pleased Heaven to adorn Ferrara — or I should rather say, the whole world — with the divine Lodovico Ariosto, there was born in the same city the painter Dosso». The «Circe» of the Borghese Gallery with her oriental luxuriousness and the languor of her entrancing eyes is in very truth Alcina; the «St. George» in the Gallery at Ferrara and that other in the Brera are not less assuredly Ruggero and Rinaldo; the forceful women of his allegorical paintings are no others than Angelica, and Bradamante, Fiordiligi and Doralice! Especially admirable are the landscapes he sets, now behind tumultuous, crowded groups as in his «Hercules and the Pygmies,» at Graz, now behind figures absorbed in meditation as in his «Vision», at Dresden, and in the Chigi picture now in the Galleria Nazionale in Rome. We have in

them dense forests, declivities carpeted with foliage rich in autumnal tints, cities and castles seemingly illuminated by flashes of lightning, sometimes set against

> *The lowering clouds, with rain and tempest pregnant,*
> *That seem to blind already sightless Night.*

Behind « Circe, » in the Borghese picture and in the extremely delightful half-nude version of the same subject in the Mond Collection in London, and behind the animals which figure in both, he has placed a sweeping forest, full of strange-hued trees and suffused by an enchanted light. We can well imagine that those trees and shrubs and animals conceal the human beings whom Circe imprisoned in them, as did Ariosto's Alcina; who

> *Throughout the fertile land some here, some there,*
> *To straight-stemmed fir trees changes; into olives some,*
> *And some to cedar trees or leafy palms —*
> *To limpid streams and fearsome beasts yet others,*
> *As best beseems her haughty witchery.*

Dosso Dossi bestowed robust beauty and ardent love on his Madonnas, of which there is an excellent example in the Galleria Capitolina. The Madonna holds a large book in both hands and suddenly turns eyes eloquent with affection towards the Child, who, held aloft by St. Joseph, throws His arms about her neck. In the background, beneath a dappled sky which grows lighter towards the horizon, are two little ships sailing on the sea. It is a scene full of happy sentiment and colour in which everything participates, from the rich garments of the Virgin to the miniatures in the book and the gentle ripples of the sea with their suggestion of coolness.

The same spaciousness was obtained by this great painter in his portraits; and these, too, may justly be described as « heroic ».

Documentary evidence had revealed the fact that Battista Luteri (died in 1548), Dosso's brother, did not spend the whole of his life as a modest painter of friezes and landscapes but did a considerable amount of figure work. We learn, moreover, that a number of pictures in various collections attributed

43

to Giovanni are really the work of Luteri. His «artistic identity» has thus been established. His rich landscapes are much fuller of detail than those of his brother and are illuminated by a pale light; his figures (and his portraits as well) are excessively heavy on account of their corpulent appearance and their great round heads, which are reminiscent of those Amico Aspertini (1474-1552) used to paint, and still more reminiscent, in their vivacious colouring of those of his fellow citizen and master, Lodovico Mazzoli (1478-1528), known as Mazzolino, to whom we are indebted for a crowd of small pictures brilliant in colouring, full of animation but containing frequent repetitions and types that are often grotesque. The older criticism was in error when it reduced Battista Luteri to the humble grade we have referred to; but Lodovico Ariosto fell into still greater error when he included him among the greatest painters, putting him with Leonardo, Mantegna, Giovanni Bellini, Michelangelo, Sebastiano del Piombo, Titian and Dosso. How true it is that the praise of poets is not to be taken at its face value! Battista was certainly inferior to his brother, although the two always worked together — and always quarrelled. He had neither the same impressiveness of form nor the same power as a colourist, although in the latter respect his work is not without depth and solidity. For the rest, the two brothers did not even share the same ideals. They went together, and lived together, first in Rome and then in Venice, where Giovanni yielded himself up completely to the splendour of Venetian painting while Battista confined his attention to reconciling his subservience to Mazzolino with a recognition of the greatness of Raphael. Yet there were other painters in Ferrara who had a deeper reverence for this supreme artist.

Benvenuto Tisi, nicknamed Garofalo (1481-1559) went first to Rome and then became a follower of Raphael, whose dignified figures and magnificent harmony of composition he tried to imitate. However, he either would not or could not renounce the characteristic method of colouring he had acquired from the example of that energetic painter, Gian Battista Benvenuti, known as L'Ortolano — who was still alive in 1529 — or a pleasing simplicity derived from the work of Boccaccino, whom he had met and admired when, as we

have already noted, he was living in Ferrara somewhere about the year 1500. But, no matter how, out of the welter of influences and masters, to whom must be added Panetti and Costa, he contrived to evolve a style of his own which, if it was not always good as regards colouring or above reproach in the matter of drawing, was at all events pleasing on account of its graceful-ness and dignity.

Comparable with his work for many reasons is that of Nicola Pisano (at work between 1500 and 1538) and Gerolamo da Carpi (1501-1566), the latter an artist well worthy of mention as architect as well as painter but some-what too inclined to wander from one style to another without possessing the ability of Garofalo and others to receive a variety of impressions and to assimilate and weld them into a style peculiarly his own. His work is scattered in many places and as a result has been attributed to a number of other paint-ers, to the considerable detriment of an artist whose merit may be said only recently to have received proper recognition.

But although Ferrarese painting continued occasionally to produce an ar-tist of note or a work of outstanding merit it at length began to lose character and continuity. Sebastiano Filippi, or Bastianino (1540-1602) tried at first to fly to the heights reached by Michelangelo but finished by using his wings on a lesser flight towards the level of Raphael, as may be seen from his «St. Ce-cilia» in the Picture Gallery at Ferrara. There was also Ippolito Scarsella, or Scarsellino (1551-1620), who warmed himself at the artistic fires of Venice and produced some delightful small pictures. The same is true of Carlo Bo-noni (born in 1569), the last painter of note produced by Ferrara and one who built up his light and shade according to the practice of the Carracci but turned to the Venetians — and especially to Paolo Veronese — in his large compositions.

★

IT WAS in the very heart of this fortunate region, where art and artists were established along the banks of the greatest river in Italy from Cremona to Ferrara, and from Piacenza to Bologna along the great Roman Via Emilia,

45

that the genius who was destined to gather up all that was best in their art and raise it to sublime heights was born. At that particular moment every school appeared to be working for the common good, with the common object of attaining to a perfection of form and colouring in keeping with local ideals. Giorgione and Titian were raising Venetian art to the highest peak of its splendour, Leonardo and Michelangelo were doing the same for the art of Tuscany while Raphael, strengthened by contact with the Florentines, was performing a similar office for that of Umbria. To Antonio Allegri — to Correggio, that is to say — fell the distinction of raising the art of Emilia to no less exalted a status, bringing it into harmony with local character in the same way as the other consummate artists already mentioned had done and were doing for their own art, stamping it with an individuality completely and definitely expressive not only of the artistic ideals but of the moral outlook of a whole people at a given moment. How is it possible, for instance, to be blind to the indelible marks of Savonarola's patriotism and grief for the fall of the Florentine Republic which are to be found in the work of Michelangelo? Or to fail to recognise in the work of Titian the pomp and luxury of heroic and opulent Venice, or in that of Raphael the gentle melancholy of the sacred region in which he grew up?

The art of Correggio, so free, so joyous and so full of fancy, is the expression of the free, joyous and fanciful character of the Renaissance as it found utterance in Emilia. In the vast and fertile fields furrowed by rivers and canals and situated, half on the northern slopes of the Apennines and half in the wide valley of the Po, there had arisen a wealth of towns, villages, castles and of cities large and small. No great and sometimes distant and mysterious political power had any dominion over them, as Rome had over the States of the Church, or such as Milan, Venice and Naples exerted over their smaller neighbours. The Emilian communities lived in more or less close contact with courts which though often small, were always illustrious and magnificent, each striving after its own ideals of culture, art, adornment and happiness; each offering a welcome to learned men, poets, musicians, architects,

painters and sculptors whose lives were devoted to beautifying the cities in which they dwelt and to increasing the joys of existence. At Ferrara there were the d'Este, at Bologna the Bentivoglio; at Novellara the Gonzaga and the Pio at Carpi. At Mirandola there were the Pico, to whose lordship Correggio himself owed allegiance; at Guastalla the Torelli; at Scandiano the Boiardo, at Parma the Rossi, at Fontanellato the Sanvitale. The Pallavicino ruled in Busseto and in Cortemaggiore, and the Rangoni at Castelvetro. To the influence of these many courts must be added that of the schools which had already arisen, and were more numerous in Emilia than in any other part of Italy. While the school of Bologna shone with a lustre greater than that of the others, there were schools at Ferrara, Modena and Parma to which pupils flocked in hundreds from various parts of Europe, bringing with them an atmosphere of well-being, animation and gaiety.

The « physical » exuberance of the region and the pleasure-loving and open-hearted nature of its people bore superlative fruit of two kinds; — the chivalrous poetry of Boiardo and Ariosto and the art of Correggio, each of which was but a different manifestation of the same impulses. When Dante wrote his « Divina Commedia » he enshrined his personages and episodes within separate and symmetrical cantos, following thus the manner of the old Gothic artists who divided their pictures into a multitude of separate panels. In the poems of Boiardo and Ariosto, on the contrary, personages and events intertwine with the utmost freedom, and there are no artificial bounds set between them. In a similar manner Correggio, as soon as he had mastered pictorial form, broke through the architectural bonds which had hitherto held painting captive and began to cover whole domes with a single composition.

Sometimes Antonio Allegri would translate his family name — so greatly in harmony with his art — into the Latin word *Laetus;* but it became the custom to call him Correggio, from the town in which he was born about the year 1490 and where he died in 1534. As will be seen, he died young; but like Masaccio, Giorgione and Raphael, he died in the full maturity of his art. The stories we are told of his early years are imaginary. We are even uncertain

47

who first taught him the art of painting, but we may surmise that he learnt the earliest rudiments from his uncle Lorenzo. Later, perhaps, he went to study under Bianchi Ferrari (died in 1510) in Modena. He certainly went to Mantua, where he would have opportunities for seeing the vast, severe paintings of Mantegna and for watching Lorenzo Costa and Dosso at their work. From his study of Mantegna's work he acquired his fervid love for perspective (for perspective as applied to the human form, that is to say, rather than to architecture), but the traditions of his birthplace, his own temperament, the example of the artists around him and the period at which he worked, all combined to deter him from the «trenchant» methods of Mantegna, although he remained faithful to him in regard to some of his conceptions and motifs. His earliest pictures, now at Florence, Milan, Paris, Strassburg, Philadelphia, London and Detroit make it abundantly clear that in his art he was an Emilian — or to be more exact, a Ferrarese — of the purest water. This very juvenile period, in which the handiwork of the learner is sufficiently manifest, was followed by another (1516-1517) in which the painter contrived to free himself from his bonds and to express himself with originality but without achieving complete success. His work exhibits the warm tints of Dosso, but the expression on his faces is not yet clearly defined and is eloquent of anxious striving. Some of his paintings and, it may be, some frescoes of this period have disappeared, but others are in existence in Naples, Florence, Rome, Madrid, Hampton Court, etc. The first real, solemn assertion of his personality is revealed at Parma, to which city he betook himself in 1518, in the decoration of the Camera di San Paolo. In allusion to the coat-of-arms of the Abbess Giovanna Piacenza, who commissioned him to do the work, which bore as a charge three moons, the artist selected — or was given — Diana as a subject. It was not the Diana who was enamoured of Endymion but «the Goddess of virgins and of chastity», who would condone nothing that offended her modesty and rewarded Actaeon with cruel punishments for having spied on her as she bathed. Diana is depicted in the upper part of the design, above the hood of the chimney. From the cornice at the top of the wall

sixteen ribs run up to the centre of the vault, where there is a coat-of-arms, forming as many panels. Correggio, developing his decorative scheme in accordance with this architectural sub-division has, mindful of the example of Mantegna, imagined a leafy arbour supported by reeds arranged in such a way as to leave sixteen openings between them. Seen through these openings, which are oval in shape, is a merry band of naked children who frolic on an invisible balcony, and whose gestures and the objects in their hands are allusive to art and to Diana's passion. The lunettes are filled with mythological subjects painted in monotone with such remarkable truth that they deceive rather than surprise the observer.

Having completed these frescoes Correggio returned to his home and hastened to finish a number of pictures in order to be free to return to Parma once more. Here he decorated the church of San Giovanni Evangelista (1520-1524) painting the walls of the apse (pulled down in 1587), the lunette of St. John, two pictures, and the cupola — the first of the «miracles» which exhibit Correggio as the complete and absolute master of all his extraordinary powers as a painter. Gigantic figures of eleven of the Apostles sit in a circle upon clouds in varied groups, each linked to the other by a crowd of tiny cherubs, giving them a certain resemblance to the antique symbolical statues of the Tiber and the Nile. The Redeemer, in the middle, ascends into Heaven surrounded by a radiant glory of little angels, who fade away at the crown of the vault into a golden haze, while the Apostle of Patmos, already grown old, kneels aloft, watching the scene with astonished but adoring eyes.

When this immense work was finished he turned once more to the painting of easel pictures, among them the «Marriage of St. Catherine» now in the Louvre, the «Noli me tangere» of Madrid and the «Madonna del San Sebastiano» at Dresden. It was not long (1526), however, before he was called upon to decorate the dome of the Cathedral at Parma as well, in which the subject chosen was the «Assumption of the Virgin». Myriads of saints and angels fly to Heaven, whirling about the Virgin, while the Apostles, full of consternation at so miraculous an event, gaze up at her from a balcony lower in the

composition; where also there are twenty-nine youths, some sitting, some prostrate; some bearing vessels or branches, or employed in kindling the fire in their thuribles, or censing the flames that burn in the sockets of eight candelabra. Looking at this stupendous work one is forced to agree with Burckhardt that here it is no longer a case of this, that, or the other figure captivating us by its beauty, grace and charm. We are brought face to face with the conviction that here the art of Correggio portrays a life that is lived in air and space. It is in this dome and in that of San Giovanni Evangelista that, as we have already mentioned, the first experiment in covering the whole of a vast curved surface with a single subject in a single composition was first made. Michelangelo himself, in the ceiling of the Sistine Chapel, adhered to the method of architectural sub-divisions containing a number of pictures; while in the ceiling of the «Stanze» Raphael had respect for the architectural arrangement of the allegorical portions and suited his design to them. Other artists had done the same in other buildings. It was left for the modest son of Emilia, born in an insignificant town amid the flat solitudes of the valley of the Po, to summon his genius to his aid and make the great attempt. And anyone who is inclined to compare the setting out of the figures on the curved wall of the vault and the foreshortening of this bold enterprise with those of Michelangelo's «Last Judgment» would do well to remember that this work is later by some years. There are nevertheless critics who see the influence of Michelangelo in some of the figures in the dome, and accordingly maintain that Allegri had visited Rome and had studied the ceiling of the Sistine Chapel, finished a short while before; thus giving the lie to Vasari, who had obtained his information in Parma itself scarcely eight years after the death of Correggio. It is possible that he may have seen figures of the Michelangelo type through the medium of drawings in the possession of some artist friend, but these presumed and partial derivations have nothing whatsoever to do with the absolutely novel «single subject» type of decoration adopted in this cupola; and in the forceful and original work of the Emilian artist are so faint that only an art critic can detect their presence, just as it is only the art critics who can see

50

traces of Mantegna in his earliest work. Why, Correggio owes no more to Mantegna or to Michelangelo than the pair of them owe to Jacopo della Quercia, Donatello or Signorelli! In overcoming the immense difficulties presented by his subject Correggio unquestionably made the utmost use of light and shade, whose secrets so many artists had striven so long to probe and only Leonardo and Giorgione had been able to discover. Are we for this reason to include Correggio among Leonardo's followers, or among those of Giorgione? By his day the fruits of the conquest of light and shade were common property, just as earlier the rules of perspective had become common property. What really happened was that it was left for Correggio to bring it to perfection.

In the almost imperceptible gradation of his tones and their perfect union and fusion Leonardo almost lost sight of the essentials of painting, which, according to him, should be capable of indicating modelling without the aid of «written» contours. But it was Correggio who carried relief into the very shadows, thus obtaining a transparency which is lacking in the work of his great predecessor and is nearly always absent from the work of the many artists who subsequently tried to imitate him. The followers of Carracci and Caravaggio were so carried away by the desire for contrast between light and shade that not one of them, even when imitating Correggio, was capable of imparting to each shadow the tone corresponding to its colour. How light were the gradations of tone with which he contrived to obtain the required effect of relief may, indeed, be gathered by examining some of his shadowed tints. In the chromatic scheme of other distinguished painters these tints would have been perceptible only in the illuminated portions. Thanks to the perfect way in which he managed his light and shade and their relation to each other—avoiding, that is to say, the opposition of excessive shadows to excessive light and thanks to his method of obtaining an effect of transparency he obtained an incomparable mastery over relief and colour. Suffused light bridges the spaces between his figures and objects, penetrates into the secondary and remoter planes, and produces a perfect illusion that every one of his creations is floating in space. Only by the employment of such unusual and conspicuous

artistic gifts could he have attempted the difficult problem of a dome covered with a «single subject» consisting of figures launched completely free upon a sea of air. So great was the novelty that at first its significance was not fully grasped. As in the case of Titian's «Assumption» and one of the «Miracles of St. Mark» by Tintoretto, there were adverse criticisms and scornful remarks. A witticism of one of the Canons of the Cathedral, to the effect that the dome reminded him of a «frog pond» acquired much popularity and seems to have given offence to Correggio, who had in the meantime painted some admirable altar-pieces such as the «Madonna del San Girolamo» and the «Madonna della Scodella» (Parma), and «Night», and the «Madonna del San Giorgio» (Dresden). We know that before he had finished the vast and splendid decoration he returned to Correggio, at the end of 1530, where he spent most of his time, busying himself with pictures and drawings of mythological subjects, even as he had made his beginning with the «Diana», and painted pictures representing «Antiope» and «The School of Love». It was at this time that he painted his «Vice and Virtue» «Danae», «Io» «Ganymede» and «Leda» for the Duke of Mantua. But this phase was not of long duration, for in the small town and in the modest house in which he had first opened his eyes he closed them on March 5th, 1534, shutting out for ever his splendid visions.

<div align="center">★</div>

VASARI, who was amazed that so remarkably «modern» a painter should have come out of the Emilia he regarded as little less than in complete bondage to the formulas of the fifteenth century—the reader will remember his story of how Francia died of grief after seeing Raphael's «St. Cecilia»—lamented the fact that Correggio did not go to Rome, «where he would have performed miracles of art and caused heart-burnings to many who in his day were considered great painters». Some students of art have considered that in Rome he would have lost his individuality, through contact with Michelangelo. For our part, we do not believe that so strong and self-reliant a personality, even more modern than either Michelangelo or Raphael, would have been affected

by any such external contacts. His method of arranging his subjects, his figures, his lighting, and even his draperies (which with him first assume a definite decorative function) all suggest an artistic outlook so entirely different from theirs that it would have been impossible for him to merge it into a fashion set by others in the way the impressionable and receptive Raphael had done.

And yet we must admit that at Correggio or Parma, where he was far from the direct influence of the ancient world and from any pressure that might have been brought to bear on him by august patrons, as well as from the criticisms and envy of other artists, he was better able to preserve his sincerity, and more free to choose subjects suited to his endowments. It was there that he was best able to develop his gifts in working out ideas and compositions of remarkable simplicity, and vastly different from the profound themes that were chosen by the two great masters of Urbino and Caprese.

Such flights of idealism as we see in the Sistine Chapel or in the Camera della Segnatura were not for him, but the simple story of Jesus ascending into Heaven with His Apostles around Him, or the Virgin borne up to eternal glory. Yet if he was not as gifted as Michelangelo or Raphael in the sober representation of nude figures or in splendour of colouring, he had an advantage over the first in transparency and over the latter in the joyous ease of his figures and their sense of movement. It is true that some authorities do not forgive so great a disregard for traditional forms, for sedateness and for symmetry; and see in the dizzy flight of the figures in his dome more of the « disorderly activity of a revolutionary » than « a step forward in the evolution of art such as we may see in the work of Titian, Michelangelo and Raphael ». But it is useless to endeavour to set boundaries to art, seeing that a genius will always leap all barriers. Even in his very earliest works Correggio showed that the fifteenth century had made but little impression on him. Indeed, it may be said that the only one of his altar pictures which shows the traditional form is the « Madonna del San Francesco », at Dresden, painted in 1515 while he was partly under the influence of the Emilians and partly under that of Mantegna. After that his own instinct forced him to be free. He did not approach the

«modern manner» by way of things merely decorative and external; he penetrated to its very core, its inspiration, its outlook, its ideals. Some artists there were in the earlier part of the sixteenth century who gave greater amplitude to their draperies and endowed their figure subjects with « portliness »; and then believed, or tried to make others believe, that they were among the moderns. But their deficient mentality revealed itself, and will always stand revealed, in the timidity and poverty of their ideas and of their composition. They resemble certain of our modern novelists and writers of comedies, who imagine they are conferring modernity on old themes by dressing the characters in their own versions in modern clothes and by substituting modern methods of lighting and transport for those which were in use among the ancients.

Correggio, on the contrary, looked at art across life itself, and even disdained to call richness in external things to his aid. He did not follow the custom of the day by introducing sumptuous fabrics and elegant costumes for the purpose of enhancing his decorative effects, nor did he avail himself of opportunities for portraiture; for he did not paint a single portrait and never included the donors in any of his other works.

Nor did the painter confine his attention solely to pictorial effect, as some would have us believe; for there is in his work a conception of the fitness of things which dominates all he did. We realise this from the need he felt for imparting an atmosphere of activity to all his figures. There are no idle people standing about, doing nothing. He was master of the art of expressing the whole sentiment of a picture in the attitudes of his figures, and this is the more remarkable because in his day it was the practice to express beauty by harmony of line rather than through harmony of sentiment. The whole of Correggio's work is instinct with movement. St. Joseph is no longer the usual morose and silent «intruder». He is alive, and participates in the joys of the Virgin. He gathers dates for the Holy Child, or is busy near by. The angels do not stand in placid contemplation but try to amuse the little Jesus by playing on musical instruments, picking leaves for His pleasure, bearing offerings of fruit, or helping the holy people by holding fruit-laden branches or tying

a donkey to a tree. His cherubs, joyously scattered everywhere, struggle under the weight of models of cities, churches, books, pastoral staves, crosses or mitres; or divert themselves by thrusting their fingers into the pot of precious ointment of the Magdalen, or trying to dress themselves in the shining armour of St. George. They seem to smile to each other even across the vast spaces of his domes, and their gestures suggest that they are halooing to their friends opposite with very little respect for the solemnity of the sacred edifice!

There is therefore in all his work a fervour of animation that is compelled to express itself in a manner in harmony with the pictorial composition. It introduces a factor that is spiritual rather than technical, obliging the artist to strive as much after the expression of what he wishes to tell us as after pictorial effect. It is thus an open question whether criticism has not in his case confused the beauty and harmony of the composition with its profound significance. The themes which occupied the attention of so magnificent a court as that of Rome, as well as the works of Michelangelo and Raphael, are certainly of greater importance and have been the subject of more extensive study, but they do not so much concern matters of art as of history and philosophy.

Correggio's outlook on art is shown in his drawings, which never — or rarely ever — reveal a careful and patient study of details or scrupulous exactitude of outline, but are merely impressions jotted down in order to settle the distribution of the figures and of light and shade. They were, indeed, not at first considered to be of much value. Vasari, who possessed several of them, wrote as follows: « If Antonio's pictures had not been as perfectly painted as we know them to have been his drawings, although pleasing and beautiful and the work of a practised hand, would not have won for him the position among artists that his extremely excellent works have done ». But the sketchy and loose drawing of his smaller sketches or jottings, often compensated by vivid flashes of animation and enchanting vigour, have been criticised far less than the drawing in his large works. In the First Edition of the « Lives » Vasari indirectly accuses Correggio of not having taken enough trouble over his drawing, because if his draughtsmanship had been as good as his colouring « he

55

would have astonished the heavens and filled the earth with his marvels». Nor was Lodovico Dolce of a different opinion: «He was better as a colourist than as a draughtsman».

This judgment having been pronounced as long ago as the sixteenth century, it is only natural that it should grow with repetition; until Mengs informs us that the drawing of Correggio was splendid and pleasing but incorrect.

It is to be noted that, after further examination, both Vasari and Mengs modified their opinions in some degree, realising, we may be sure, that the faults are few in comparison with their tremendous mastery in so many other respects. Taking into consideration, as we must, the knowledge of the human form exhibited by Correggio, so free in its novel and unexpected movement; and considering at the same time the infinite variety of treatment displayed in the hands and feet — hundreds of hands folded in a hundred different ways or grasping other hands, and hundreds of feet — one is immediately struck with amazement, and convinced that no other artist in the world ever set himself so many problems and solved them all. His retentive memory and his powers of deduction were of invaluable help to him; and his intuition served him in solving hitherto un-met problems of foreshortening, as though it were some Cyclops standing before him, siezing human bodies in his powerful hand and hurling them naked into the air so that the artist might study and record their attitudes. It is here that his real greatness lies, for, as Vasari says, «he was most marvellous in overcoming every difficulty». We have a complete estimate of his merits when we add to the words of Vasari the opinion expressed by Burckhardt, that from the point of view of technique Correggio reached the last and highest development of Italian art. Ludwig Tieck sang of him: «What Genie opened for thee so many treasure houses? All the imagery in the world came out to meet thee, and full of love abandoned itself to thy embrace. How joyous the expectant throng as the laughing angels held thy palette and lordly spirits stood out in splendour to be thy models while sweetest harmonies filled the vault of Heaven! Let no one claim knowledge of the sublimest secrets of art who has not seen thee and thy dome, O Parma!»

56

CORREGGIO'S direct and immediate influence was small, and the number of his followers few; but it was not so weak as to warrant the silence observed with regard to it by some historians of art. Giorgio Gandini del Grano (1480?-1538) showed power as a draughtsman, but his pictures are heavy as regards colouring and his compositions too crowded. Francesco Maria Rondani (1490-1550?), on the other hand, was somewhat abrupt in execution, but pleasing on account of his broad simplicity and harmony of composition and the vivacity of his colouring. Michelangelo Anselmi (1491-1554) was the most pleasing of Correggio's pupils. His figures are full of movement, his tones warm and luminous and his technique flowing. He was born in Lucca, his father being an exile from Parma. From Lucca Anselmi went to Siena and came under the influence of Sodoma, but went finally to Parma about the year 1518, where Correggio arrived at about the same time and immediately exerted a decisive influence over him.

Francesco Mazzola, called « Il Parmigianino », was, however, superior to all of them, and was only inferior to Correggio himself in all the group of Parmese painters. Born in 1503, he was the son of Filippo Mazzola, a poor painter of sacred subjects but a good portraitist. Parmigianino's first lessons were learnt in the workshop of his uncles Pier Ilario and Michele, both of them inferior as artists even to Filippo. Thus his path was not marked out for him until Correggio came to decorate the Camera di San Giorgio. It must not, however, be supposed that he became Correggio's servile follower. The vivacity of his temperament led him to sound a strong personal note which remained clear and distinct even when in 1523 he went to Rome to study the works of Michelangelo and Raphael. He remained there some years, and only fled when he was driven from the city by the terrible sack of 1527. He stopped in Bologna and there executed a number of pictures, the chief of them being the « St. Margaret » and the « St. Roche ». Shortly after the coronation of Charles V, whose portrait he painted, Parmigianino returned home and undertook to decorate the vault of the presbytery, the ceiling of the apse and the cupola of the church of the Steccata with frescoes. He did not do much and that little

57

was done unwillingly, for his character was one that chafed under discipline. He had, moreover, « begun to study alchemy ». Bitter quarrels arose as a result between him and the church authorities. He grew irritated and went away from Parma. It was then that he became the guest of the Sanvitali at Fontanellato, where he painted the fable of Diana and Actaeon in fresco in the ceiling of a small room. In 1495 he renewed the contract for the work in the Steccata and set hand to it, but fresh dissensions arose almost from the start, with the result that of the great work originally contemplated only a few figures were actually completed. Infuriated at last by the threats of the church authorities, and perhaps doubtful whether in view of what had been achieved by Correggio in the two domes near by he was capable of giving satisfaction in the very considerable task he had undertaken, he left precipitately — one might almost say that he fled — to Casalmaggiore; and there in a short time he fell sick and died, at the early age of thirty-seven years.

It has been very properly urged that Parmigianino's figures are disproportionately long. Albani says that he was « intent only on portraying nymphs ». It is certainly true that the gracefulness of Correggio often becomes in his work unsubstantial and effeminate. It cannot, however, be denied that he possessed great ability as a draughtsman, a quality much admired by Paolo Veronese; excellent judgement in his selection of subjects, and a gay and vivacious colouring. His draperies, also, although mannered and often copied from the antique, are exquisitely light and delicate. His portraits, too, are very beautiful and full of nobility.

Girolamo Mazzola Bedoli, who was born in Parma about the year 1500 and died there in 1569, derived his art from Parmigianino and Correggio and also from the Modenese sculptor Antonio Begarelli. From Parmigianino he acquired his scrupulous precision of outline; from Correggio his diaphanous colouring with its half-tones and shadows of extreme delicacy; from Begarelli sedateness and a sculptural quality. He nevertheless developed a style of his own which is readily distinguishable from those of his teachers by the bias towards classicism exhibited in his figures and the cristalline, irridescent tones

of his accessories. These qualities are all of them very noticeable in his large and complicated picture of the «Conception».

With the death of his son Alessandro (1533-1608) the artistic continuity of the Mazzola came to an end, and with the death of Pomponio, (1521-1593), son of Correggio, that of the Allegri. Both families, after having produced several painters of note, ended in mediocrity. But it would not be fair to be too severe in the case of Pomponio, who was mediocre, it is true, but not worse than that. He has been crushed by the fame and greatness of his father; but in his work there still flash out, though in a less pronounced form, a certain vivacity in composition, beauty of form, smiling faces and depth of background. His «Charity» (Ravenna) is cast in an original and modern form.

With the artists above mentioned the influence of Correggio ceased, and there supervened a period in which his work could win no more than a limited and frigid admiration. When dealing with the painters of Cremona, and especially with Sojaro, in an earlier part of this work we took occasion to refer to the condition of affairs, saying that the artists of Emilia preferred to look towards Rome. Putting aside the names of minor painters, the following were perhaps the only exceptions to the rule: — the pleasing Gaspare Pagani of Modena (born in 1513), the uncouth Lelio Orsi of Novellara (1511-1587) and — in Bologna — Lorenzo Sabbatini (1530-1577), Orazio Sammacchini (1532-1577), Bartolomeo Passarotti (1540-1612), etc. These men, despite the great fame of the Roman school and the general encouragement to remain strictly faithful to it, gradually turned towards the art of Correggio, an art at that time in little repute. They are artists with excellent and pleasing qualities, but they hesitate too much as to whether their feet shall follow one path or the other. The movement and gaiety of Correggio holds them in thrall, but they are unwilling to give up, for instance, the false effect produced by the «contrasted colours» born of the Raphaelesque tradition: the nude figures of Correggio, so lightly modelled by the play of light and shade, enchant them, yet they will not renounce the muscular development that had its being first in the work of Michelangelo. Pellegrino Tibaldi, to whom we have already

referred, set out with greater determination along the Roman path in company with Tommaso Laureti (1508-1592) of Palermo, who lived many years in Bologna, Prospero Fontana, the founders of the school of Fontainebleau, and others.

But the glorious hour of Correggio came at last. The cry went forth from the Carracci, who realised that the figures painted by the followers of Raphael and Michelangelo had grown feeble. The Carracci would have none of such figures, and turned back to those others — still full of vigour — which had been painted by Correggio and Titian. We may not here speak of the Carracci, for although born at the beginning of the second half of the sixteenth century they and their art belong to the succeeding century, as does that of the Procaccini, who also looked towards Parma for inspiration. We may, however, say that for artists Parma became a veritable Mecca, no less than Florence, Venice or Rome. Nearly every one of the Genoese painters travelled the long road beside the Bisagno and the Trebbia, working down to Piacenza and thence across the plain to Parma. Valerio Castello and Gregorio and Lorenzo de' Ferrari made a long sojourn there. The Carracci and Aretusi went there and made elaborate copies, and after them the whole of the Bolognese may almost be said to have followed in a body.

Among others from the Veneto went Pietro Liberi, Sebastiano Ricci and the great Tiepolo; from Rome Andrea Sacchi, who used to say that his heart « had remained behind in Parma »; from remote Calabria came Mattia Preti who, as Baldinucci tells us, « remained there a long time studying these stupendous paintings ». Not less numerous was the pilgrimage that set out from Tuscany. It included Gregorio Pagani, Andrea Comodi; the Sienese Francesco Vanni; Cristofano Allori, and Baldassare Franceschini of Volterra; and when someone told Baldinucci that Lorenzo Lippi had passed through Parma without stopping « to see the marvellous cupola » he said that such a thing was « absolutely incredible ».

Nor was the influence of Correggio confined to artists who visited Parma. The chiefest and most original part of Correggio's design — the covering of

vaults and cupolas with a single composition of human figures drawn in perspective — was copied everywhere and became, so to speak, a definite and unavoidable feature of all decorative schemes. His pioneer effort was followed in Parma by the cupolas painted by Sojaro, Giambattista Tinti (1558-1604) and Antonio Bernabei (1567-1630) — all of them painted with unwarranted audacity in close proximity to those of Correggio. Then there were the cupolas done by the masters of the Bolognese school: — Guido Reni, Domenichino, Lanfranco, Lionello Spada, Cignani and Mancini; the splendid Roman vaults of Baciccia, Padre Pozzo, Pietro da Cortona, as well as the no less joyous ones painted by the Neapolitan group which included Giordano, Solimena, De Matteis and De Mura. There were the decorative pageants of Tiepolo, the delightful caprices of the Piedmontese Beaumont. And, away on the other side of the Alps, the eighteenth century saw the creation in France of a wealth of painted decoration in which whole bands of Correggio's joyous, boisterous cherubs played an important part. Even elsewhere one may often come upon some of Correggio's angels, flitting across the painted vaults and domes of other artists, carrying with them a note of joy and a sparkle of beauty.

In the meanwhile his pictures scattered throughout Europe evoked the admiration of artists of every school. Bartholomew Spranger (1546-1611) acclaimed him as the greatest of all modern painters. David Teniers the Younger included a copy of the «Christ in the Garden» in his «Artistic Studies», while another Flemish painter placed a copy of the «Antiope» in his so-called «Atelier d'Apelle». In Holland the great Rembrandt himself did not disdain to imitate this same work in one of his etchings, and it also appears as one of the figures in a picture by another artist.

In Spain Francisco de Ribalta showed himself to be of the school of Correggio as far as his method of lighting his figures is concerned; and it must not be forgotten that El Greco and Ribera went to Parma especially to study Allegri's paintings and were, each in his own way, admirers of his work.

Reynolds in England included him among the «ideal masters», and when

William Hogarth painted his picture, «The Countess's Boudoir», he depicted the «Io» now in Vienna as among the works of art hanging on the walls.

But it is above all in France that his ardent spirit is cherished and understood. In the seventeenth century François Spierre had already engraved one of Correggio's Madonnas, and Louis de Boulogne had engraved the «Leda». During the eighteenth century admiration for this artist increased. Boucher drew inspiration from him for some of his undraped mythological figures, as did Carl van Loo for his «Danae», and Fragonard for the «Antiope» which Géricault copied. When Fragonard's picture representing a group of cherubs flying in mid air was exhibited at the Salon in 1767 Diderot, imitating the Canon of Parma's *bon-mot* about the dome of the cathedral without improving on it, said that it looked like «a large dish of fried cherubs». .

In the same way, Correggio's lighting effects and his types of nude figures reappear in the «Rape of Psyche» and other pictures by Pierre Prud'hon; in the «Nymphs Bathing», by Corot; in the «Dream of Happiness» by Constance Mayer; the «Confidences d'Amour», by Narcisse Diaz and in some of the pictures of Jean Henner, who died at the beginning of this century. So great, indeed, was Correggio's influence in France that it is even recognisable in the work of some of her sculptors, such as Adam, Michelange Glodtz and Falconet.

For the rest, let us not forget that the spirit of Correggio still lives also in Italy in the work of facile modellers in stucco such as Rusconi, Raggi, Fancelli and Ferrata, and that Lorenzo Bernini perhaps drew his first inspiration for his «Ecstasy of St. Theresa» from the «Danae» of the Master.

Antonio Allegri is thus the greatest artistic genius produced by the vast south-western area of Northern Italy during the sixteenth century. He is a mighty Voice singing of inspiration, joy and beauty a song whose cadences have floated to every corner of Italy and even beyond her borders. Who shall say that the last notes have yet died away?

INDEX

Abate, Niccolò dell', 40.

Adam, family, 62.

Agresti, Livio, 40.

Alba, Macrino d', 18, 19.

Albani, Francesco, *cit.* 58.

Aleni, Tomaso (« Il Fadino »), 33.

Allegri, Antonio (*v.* Correggio).

Allegri, Lorenzo, 48.

Allegri, Pomponio, 59.

Allori, Cristofano, 60.

Ambrosi, Melozzo degli (*v.* Melozzo da Forlì).

Anguissola, Sofonisba, 35.

Anselmi, Michelangelo, 57.

Antonello da Messina, 10.

Appiano, Nicola d', 32.

Aretusi, Cesare, 60.

Ariosto, Lodovico, *cit.* 41, 44, 47.

Aspertini, Amico, 44.

Azeglio, Roberto d', *cit.* 31.

Baciccia, Gaulli G. B., called, 61.

Bagnacavallo (*v.* Ramenghi, Bartolomeo).

Baldinucci, Filippo, *cit.* 27, 60.

Bandello, Matteo, *cit.* 7.

Barisini, Tomaso, 38.

Bastianino (*v.* Filippi, Sebastiano).

Bazzi, Giovanni Antonio (*v.* Sodoma).

Beaumont, Carlo, 61.

Bedoli, Girolamo Mazzola, 35, 58.

Begarelli, Antonio, 58.

Bellini, Giovanni, 44.

Bembo, Gian Francesco, 34.

Bembo, Pietro, 34.

Benvenuti, Gian Battista («L'Ortolano»), 44.

Bergognone, Ambrogio, 8, 9, 32, 39.

Bernabei, Pier Antonio, 61.

Bernini, Lorenzo, 62.

Bertucci, Giacomo, 40.

Bianchi Ferrari, Francesco, 48.

Boccaccino, Antonio, 33.

Boccaccino, Boccaccio, 33, 44.

Boccaccino, Camillo, 34.

Boiardo, Matteo Maria, *cit.* 47.

Boltraffio, Giovanni Antonio, 10, 12.

Bonasone, Giulio, 39.

Bononi, Carlo, 45.

Botticelli, Alessandro, 20.

Boucher, François, 62.

Boulogne, Louis de, 62.

Bramante, Donato, 5, 8, 10, 12, 13, 17, 25.

Bramantino, Bartolomeo (Suardi), 8, 12, 13, 14, 17, 24, 27, 33.

Burckhardt, Jakob, *cit.* 50, 56.

Butinone, Bernardino, 8, 13.

Calvi, Lazzaro, 37.

Calvi, Pantaleo, 37.

Cambiaso, Luca, 36.

Campi, family, 34.

Campi, Antonio, 34.

Campi, Bernardino, 35.

Campi, Giulio, 34.

Cane, Ottaviano, 19.

Caprotti, Gian Giacomo («Il Salai»), 11, 12.

Caravaggio, Polidoro da, 36.

Carpaccio, Vittore, 38, 39.

Carpi, Girolamo da, 45.

Carracci, family, 60.

Carracci, Annibale, 42.

Casella, Francesco, 33.
Castello, Valerio, 60.
Cavenaghi, Luigi, *cit.* 12.
Cesariano, Cesare da Reggio, 13.
Cignani, Carlo, 61.
Cima, G. B. da Conegliano, 33.
Civerchio, Vincenzo, 8.
Comodi, Andrea, 60.
Conti, Bernardino de, 11, 12.
Corot, G. B., 62.
Correggio (Antonio Allegri), 9, 14, 15, 22,
 26, 28, 33, 35, 36, 41, 42, 46, 62.
Corte, Valerio, 37.
Cortona, Pietro Berrettini da, 61.
Cosimo, Piero di, 10.
Cossa, Francesco del, 38.
Costa, Ippolito, 35.
Costa, Lorenzo, 38, 42, 45, 48.
Cotignola (*v.* Marchesi Girolamo).
Cozzarelli, Giacomo, 26.
Crivelli, Carlo, 28.

Dante Alighieri, *cit.* 47.
Dente, Marco, 39.
Diaz, Narcisse, 62.
Diderot, Paul, *cit.* 62.
Dolce, Lodovico, *cit.* 56.
Domenichino (Domenico Zampieri), 61.
Donatello, 51.
Dossi, Battista, 43, 44.
Dossi, Dosso, 34, 35, 40, 42, 44, 48.

Emilia, painters of, 38.

Fadino, Il (*v.* Aleni, Tomaso).
Falconet, Etienne Maurice, 62.

Fancelli, Cosimo, 62.
Ferrara, painters of, 38, 42.
Ferrari Altobello (« Il Melone »), 33.
Ferrari, Bianchi Francesco, 48.
Ferrari, Gaudenzio, 12, 14, 17, 18, 27, 33, 36.
Ferrari, Defendente de, 17, 18.
Ferrari, Eusebio de, 18.
Ferrari, Gregorio de, 60.
Ferrari, Lorenzo de, 60.
Ferrara, Ercole, 62.
Figino, Ambrogio Giovanni, 32.
Filippi, Sebastiano (« Bastianino »), 45.
Fontainebleau, school of, 41, 60.
Fontana, Lavinia, 40.
Fontana, Prospero, 40, 60.
Foppa, Vincenzo, 9, 12.
Forlì, Melozzo da, 13, 24, 38.
Fragonard, Jean Honoré, 62.
Francesca, Piero della, 13, 38.
Franceschini, Baldassare, 60.
Francia (Francesco Raibolini), 1, 2, 19, 38,
 39, 52.
Francucci, Innocenzo, da Imola, 40.

Gandino del Grano, Giorgio, 57.
Gandolfino, 19.
Gaudenzio (*v.* Ferrari, Gaudenzio).
Garofalo (*v.* Tisi, Benvenuto).
Gatti, Bernardino (« Il Sojaro »), 34, 35,
 59.
Gaulli G. B. (*v.* Baciccia).
Genga, Girolamo, 40.
Genoa, school of, 37.
Géricault, Jean, 62.
Ghirlandaio, Domenico, 20.

66

Giampietrino (*v.* Rizzi, Gian Pietro).
Giordano, Luca, 61.
Giorgione da Castelfranco, 13, 42, 46, 47, 51.
Giovenone, Girolamo, 17, 18, 31.
Giovenone, Giuseppe, 27.
Giulio Romano (Pippi), 34, 40, 41.
Glodtz, Michelange, 62.
Gobbo, il (*v.* Solario, Cristoforo).
Grandi, Ercole, 38.
Granmorseo, Pietro, 19.
Grano, del (*v.* Gandino, Giorgio).
Greco, el (Domenico Theotocopulos), 61.

Henner, Jean, 62.
Hogarth, William, 62.

Landi, Gaspare, 19.
Lanfranco, Giovanni, 61.
Lanino, Bernardino, 27, 31, 32.
Lanzi, Luigi, *cit.* 28, 31.
Laureti, Tommaso, 60.
Leonardo da Vinci, 1, 11, 12, 14, 17, 22, 23, 28, 44, 46, 51; the Last Supper, 2, 6, 7, 8, 12, 13; the Virgin of the Rocks, 6, 7, 11.
Liberi, Pietro, 60.
Liguria, painters of, 36.
Lippi, Lorenzo, 60.
Lodi, Agostino da (« Pseudo-Boccaccino »), 14.
Lomazzo, Giovan Paolo, *cit.* 12, 29, 31.
Lombard schools, 7.
Longhi, Luca, 40.
Luciani (*v.* Piombo).
Luini, Bernardino, 11, 12, 14, 16, 27, 36.
Luteri (*v.* Dossi).

Magni, Cesare, 11, 12.
Malosso, il (*v.* Trotti, Gian Battista).
Mancini, Francesco, 61.
Mantegna, Andrea, 19, 44, 48, 49.
Maratti, Carlo, 19.
Marchesi, Girolamo (« Cotignola »), 39.
Marchetti, Marco, 40.
Masaccio, 47.
Matteis, Paolo de, 61.
Mayer, Constance, 62.
Mazzola, Alessandro, 59.
Mazzola, Filippo, 57.
Mazzola, Francesco (« Il Parmigianino »), 35, 57.
Mazzola, Girolamo (*v.* Bedoli).
Mazzola, Michele, 57.
Mazzola, Pier Ilario, 57.
Mazzoli, Lodovico (« Mazzolino »), 33, 44.
Mazzone, Giovanni, 19.
Melone, il (*v.* Ferrari, Altobello).
Melozzo da Forlì, 13, 24, 38.
Melzi, Francesco, 11, 12.
Mengs, Raphael, *cit.* 66.
Menzocchi, Francesco, 40.
Messina, Antonello da, 10.
Michelangelo Buonarroti, 2, 9, 13, 26, 28, 44, 45, 50, 52, 55, 57.
Moretto (Bonvicino, Alessandro), 36.
Moroni, G. B., 36.
Mura, Francesco de, 61.

Napoletano, Francesco, 11, 12.
Oggiono, Marco d', 11, 12.
Orsi, Lelio, 59.
Ortolano (*v.* Benvenuti, Giovanni Battista).

PLATES 1-84

I

LEONARDO
The Last Supper
SANTA MARIA DELLE GRAZIE. MILAN
Photo Alinari

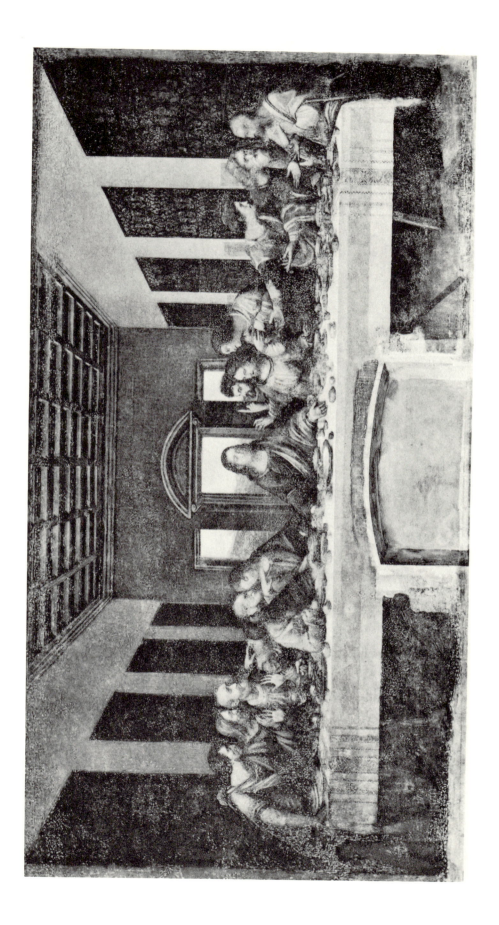

2

LEONARDO
Detail from the Last Supper
SANTA MARIA DELLE GRAZIE. MILAN
Photo Alinari

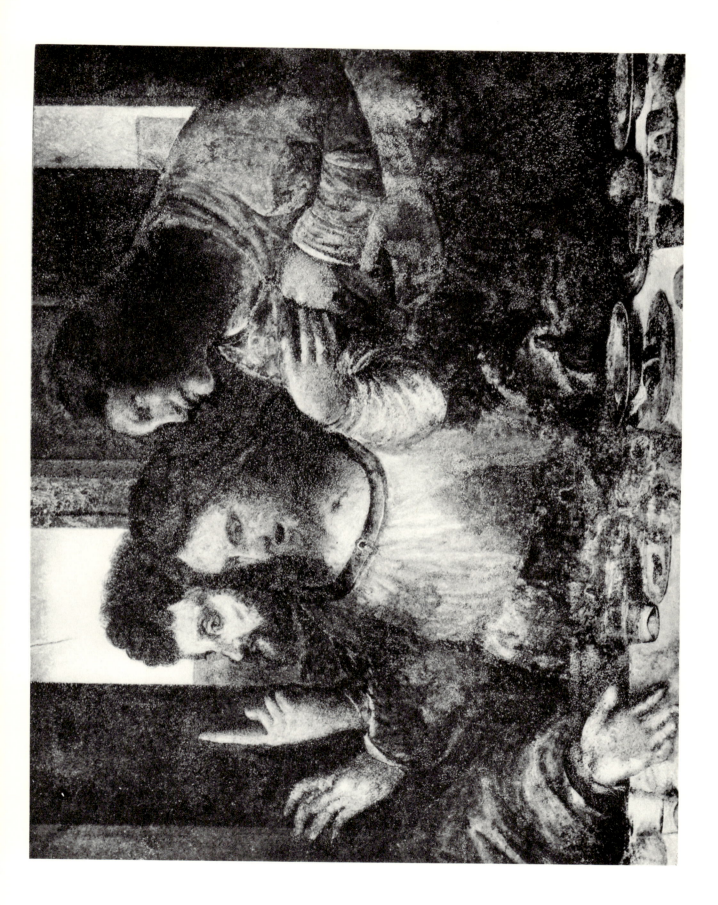

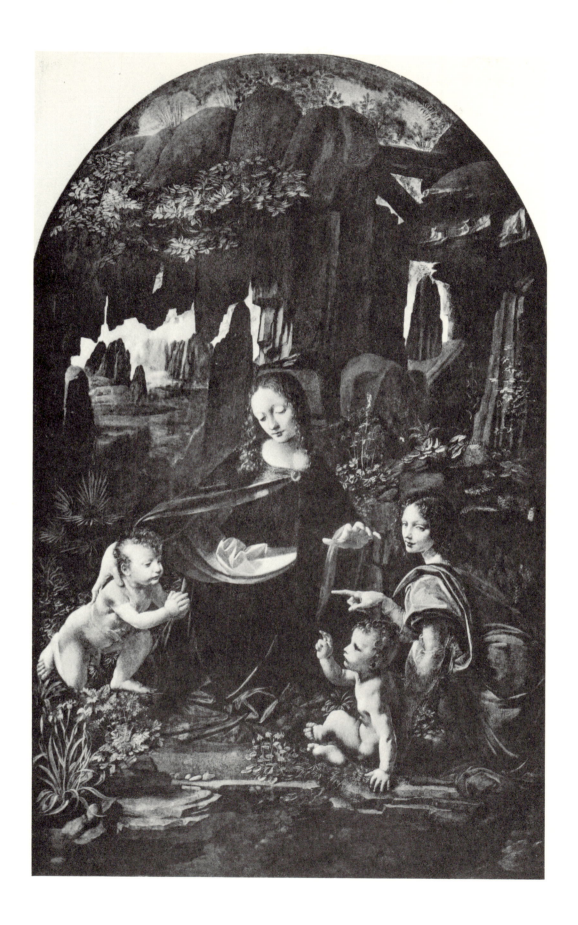

4

LEONARDO
The Virgin of the Rocks
NATIONAL GALLERY. LONDON
Photo Anderson

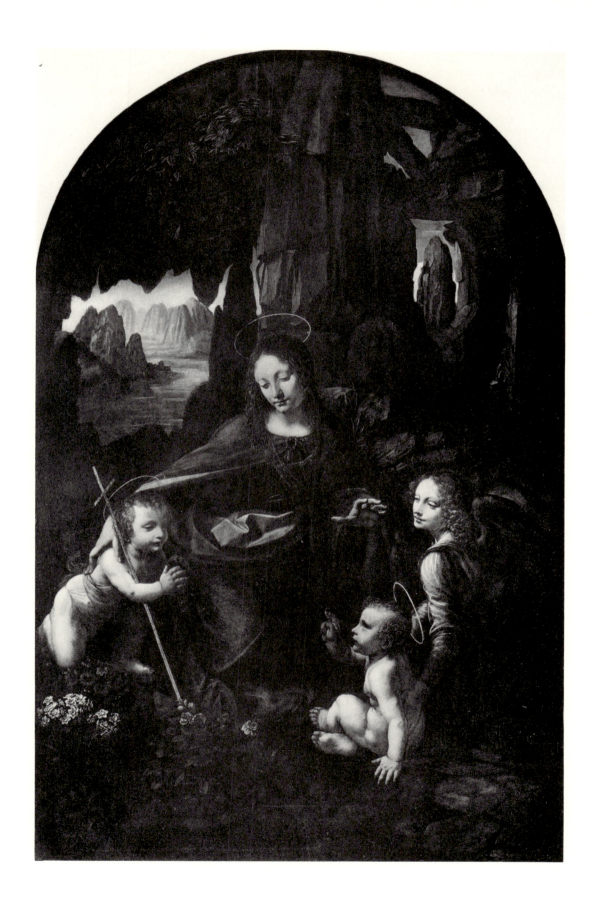

5

AMBROGIO DE PREDIS
Angel, from « The Virgin of the Rocks »
NATIONAL GALLERY, LONDON
Photo Anderson

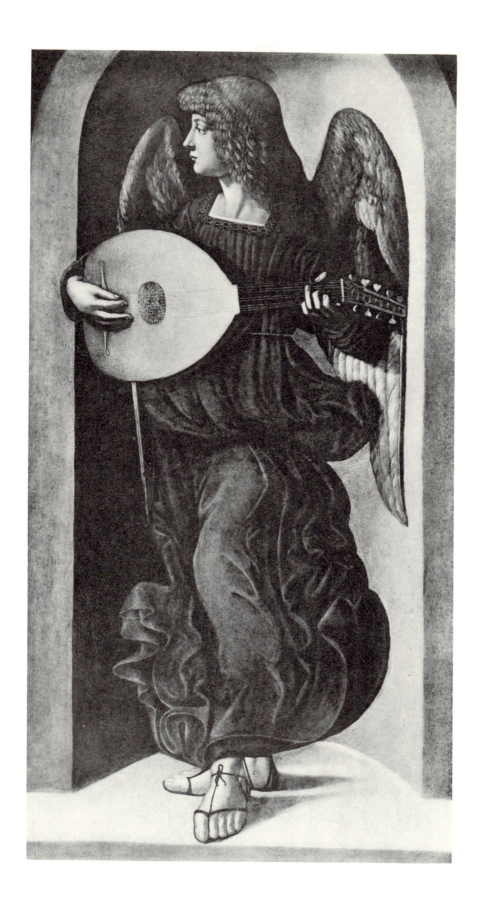

6

ANDREA SOLARIO
The Sojourn in Egypt
Poldo Pezzoli Museum. Milan
Photo Alinari

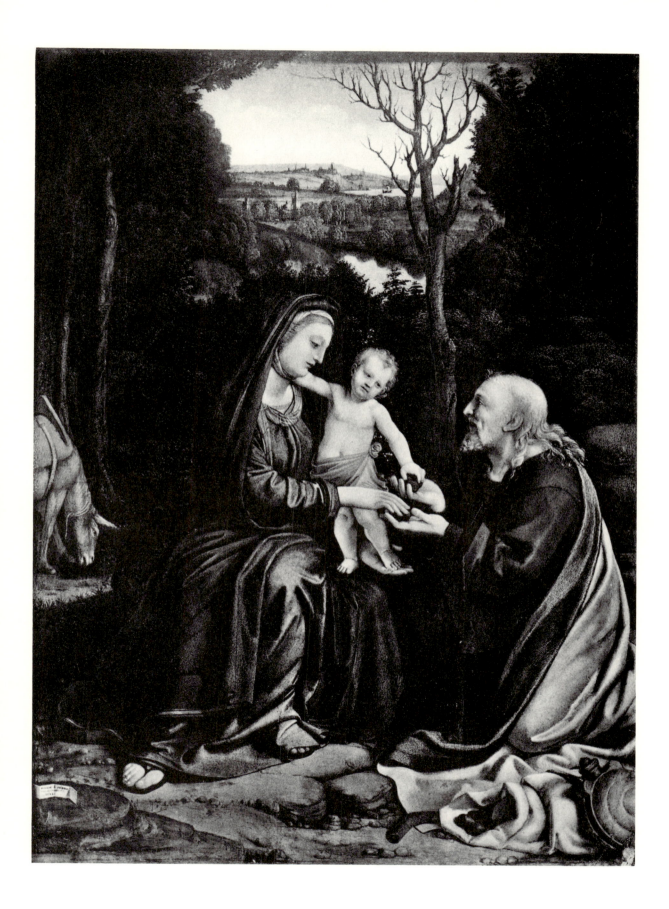

7

ANDREA SOLARIO

Portrait of a Man

PINACOTECA. MILAN

Photo Alinari

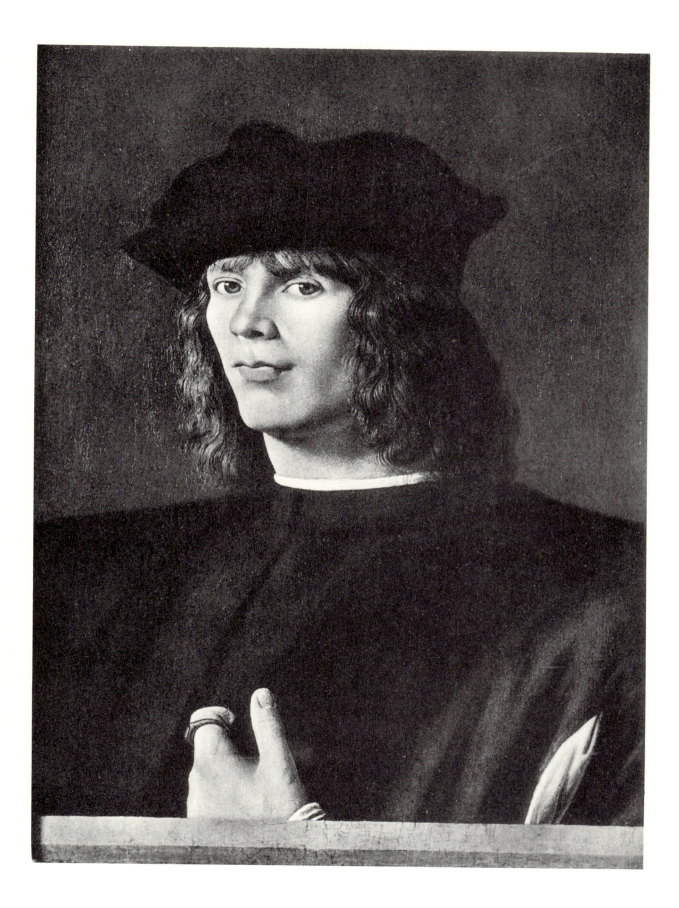

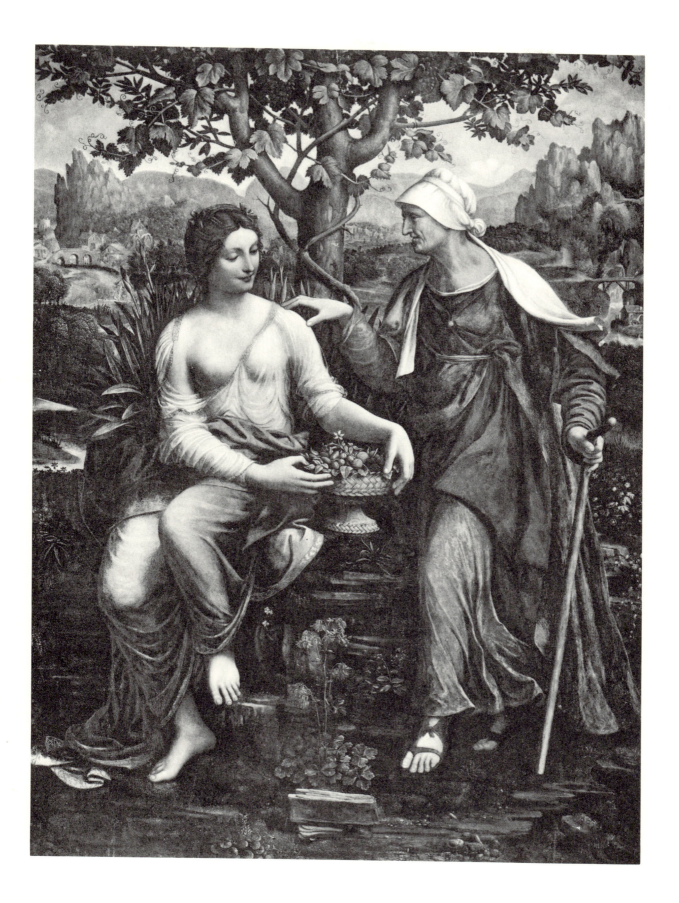

IO

MARCO D'OGGIONE
The Archangels
BRERA. MILAN
Photo Alinari

II

CESARE DA SESTO
The Adoration of the Magi
MUSEUM. NAPLES
Photo Brogi

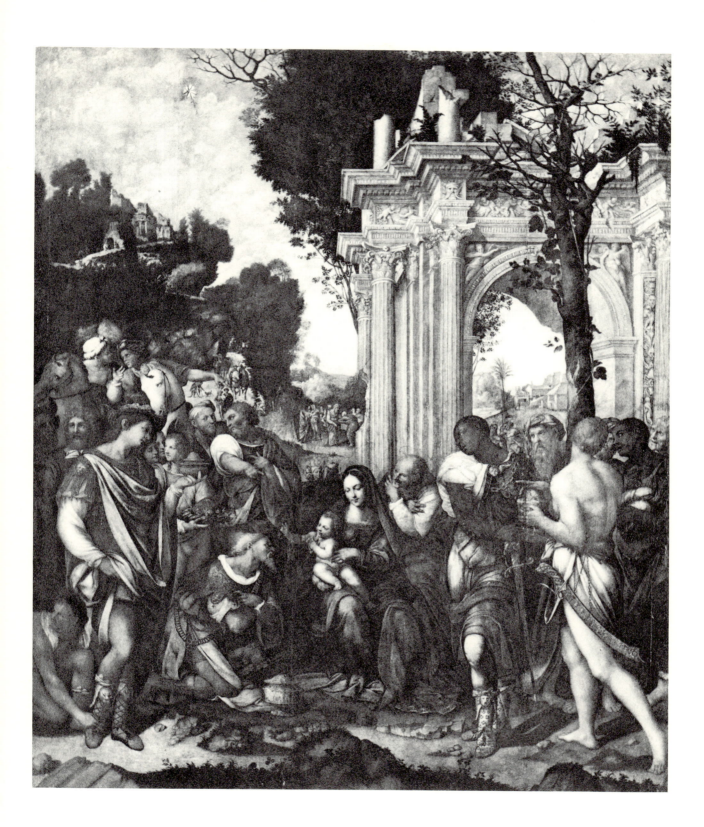

12

GIAMPIETRINO
Madonna and Child between SS. Catherine and Jerome
MUSEUM. NAPLES
Photo Anderson

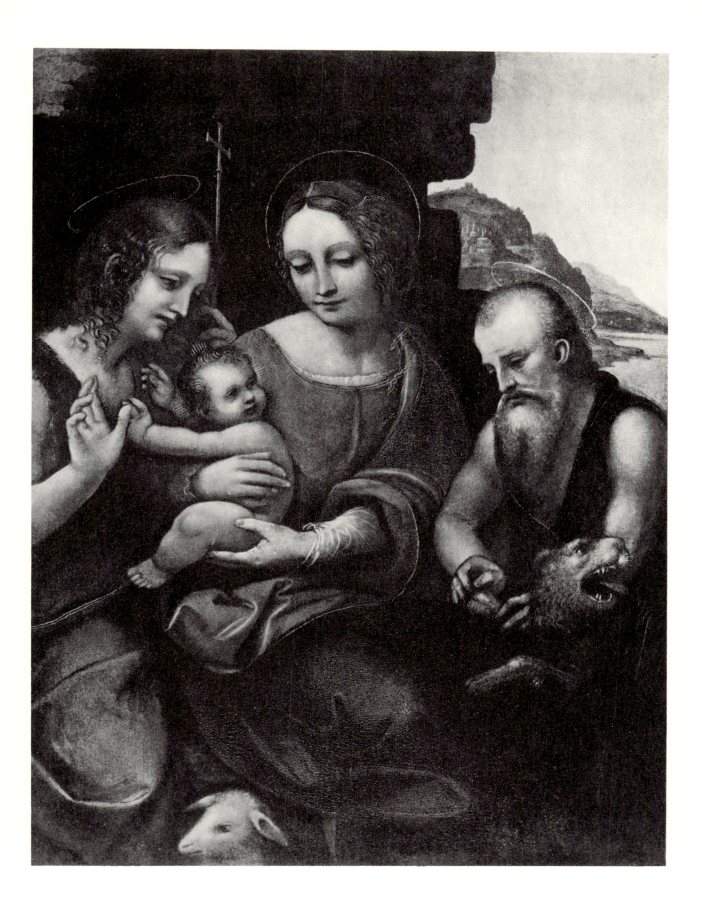

I3

CESARE MAGNI

Holy Family

BRERA. MILAN

Photo Brogi

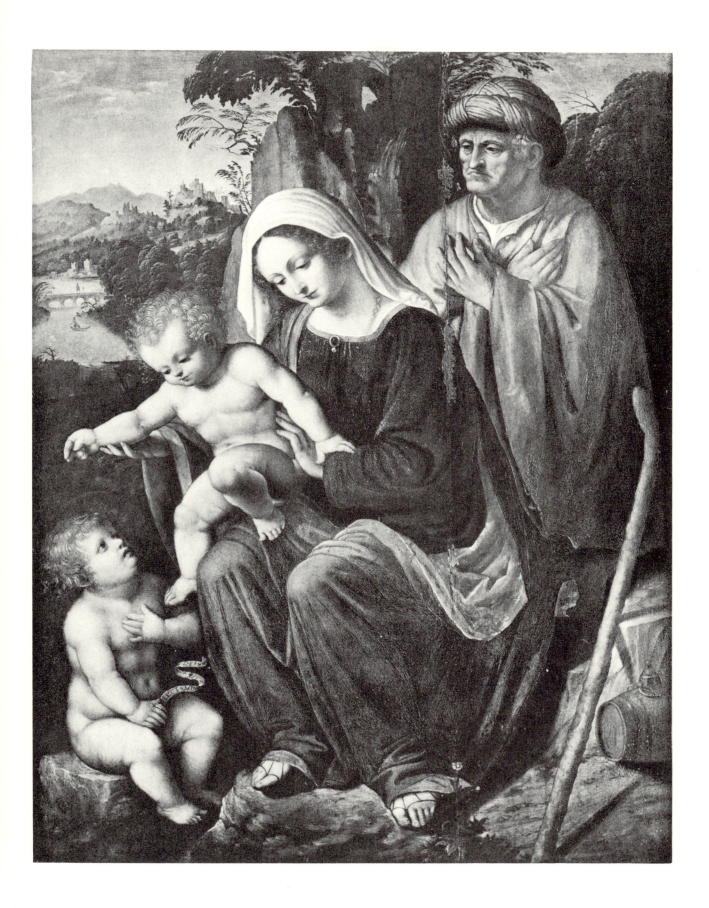

14

FRANCESCO NAPOLETANO

Madonna and Child

BRERA. MILAN

Photo Alinari

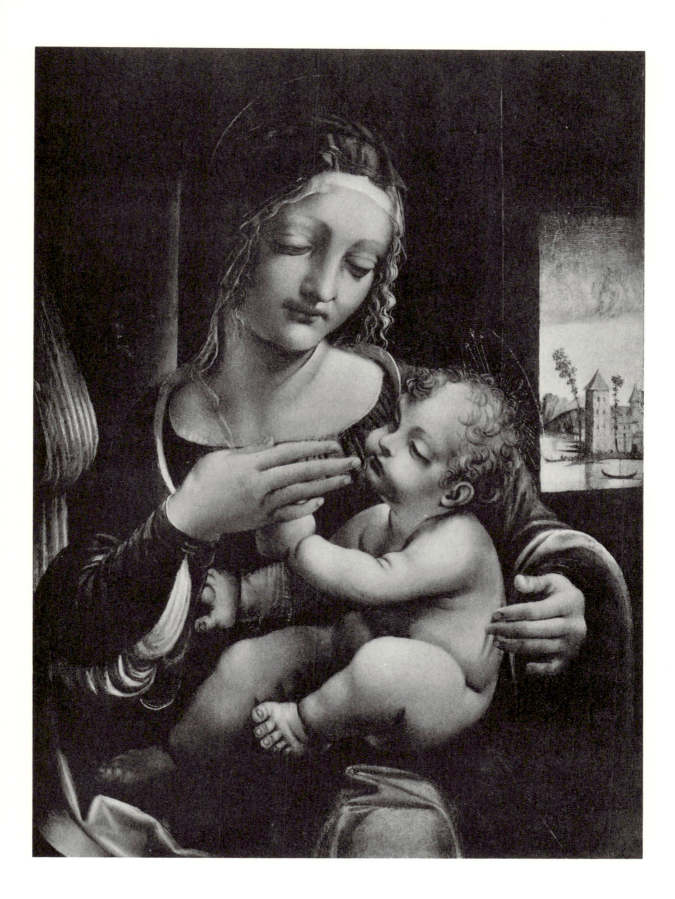

15

BRAMANTINO

Triptych

BIBLIOTECA AMBROSIANA. MILAN

Photo Brogi

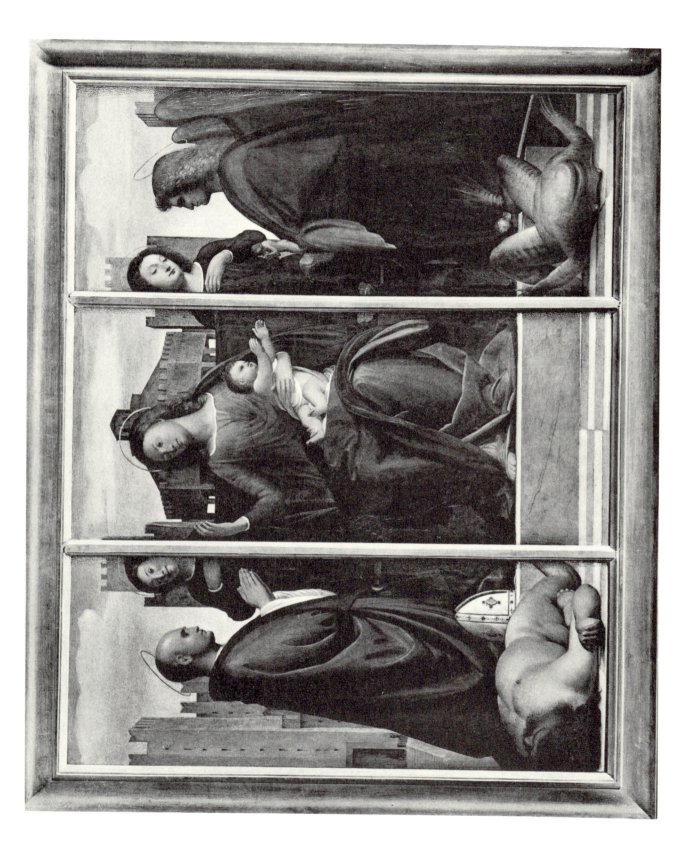

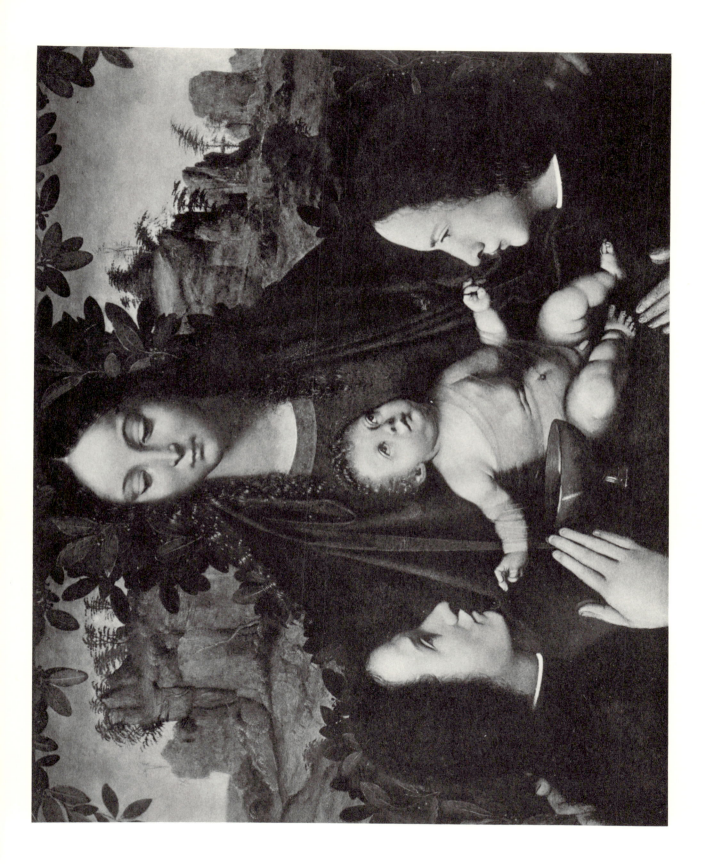

I7

BERNARDINO LUINI
Madonna and Child and Nun
FILANGIERI MUSEUM. NAPLES
Photo Alinari

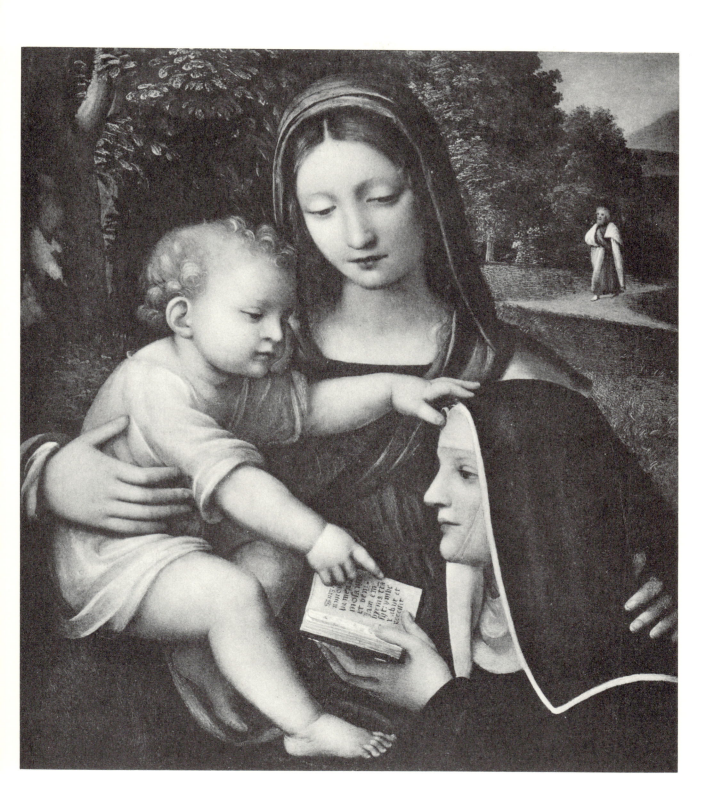

18

BERNARDINO LUINI

Ippolita Sforza with SS. Scolastica, Agnese and Lucia

MONASTERO MAGGIORE. MILAN

Photo Anderson

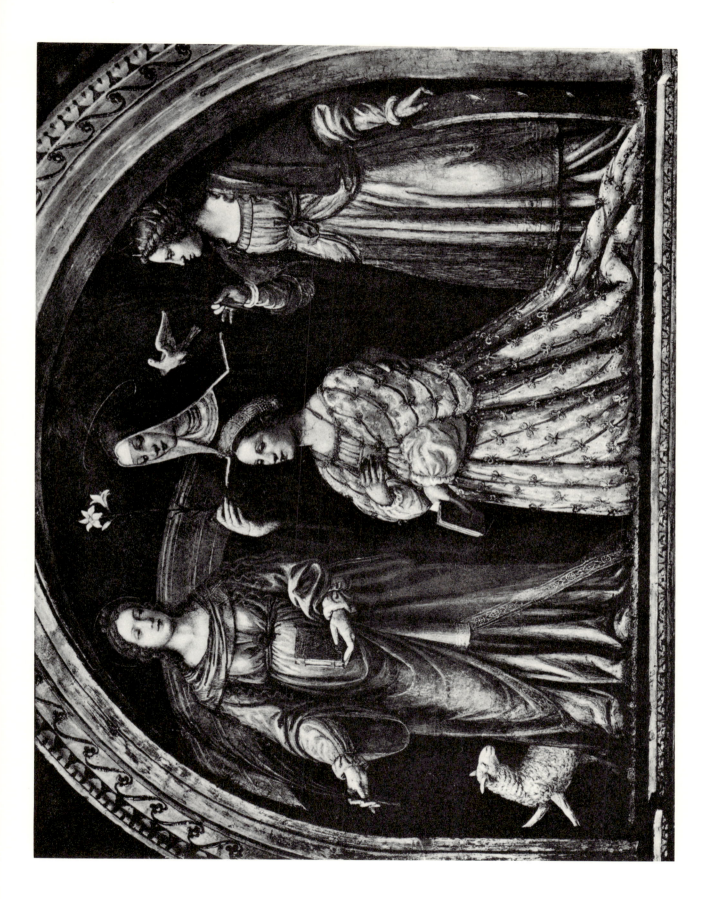

19
BERNARDINO LUINI
The Body of St. Catherine carried to the Tomb
BRERA. MILAN
Photo Alinari

20

MARTINO SPANZOTTI
Madonna and Child
PINACOTECA TURIN

Photo Anderson

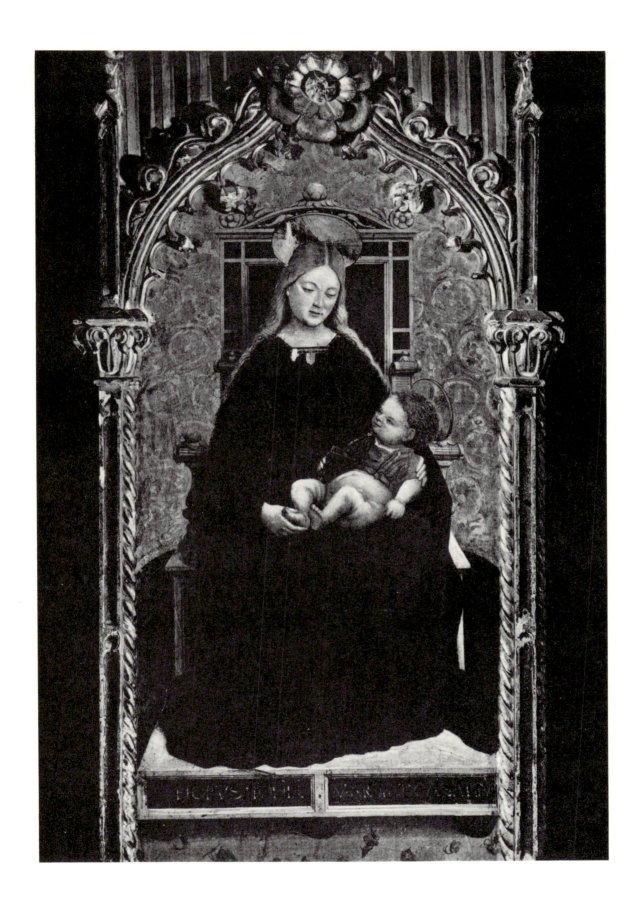

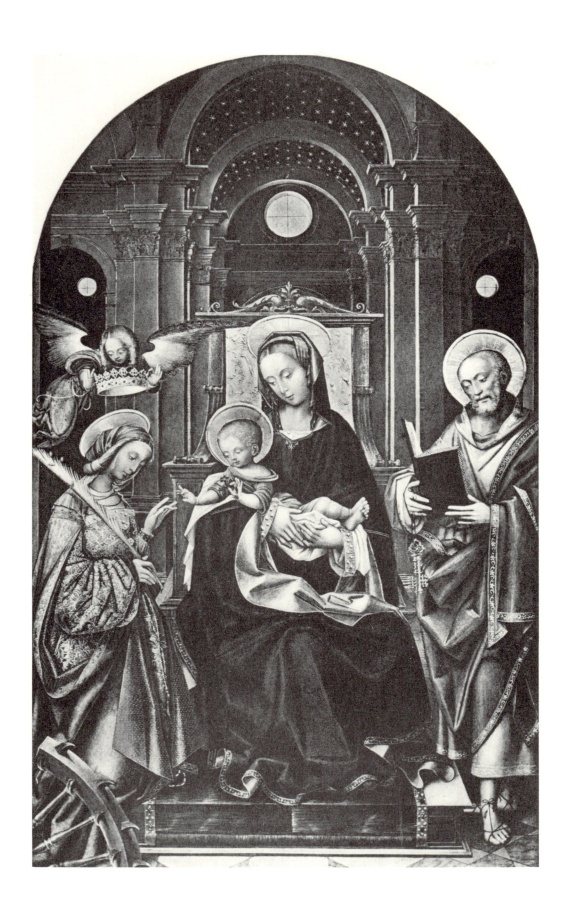

22

GIOVENONE
Madonna and Child with Saints and Donors
PINACOTECA. TURIN
Photo Brogi

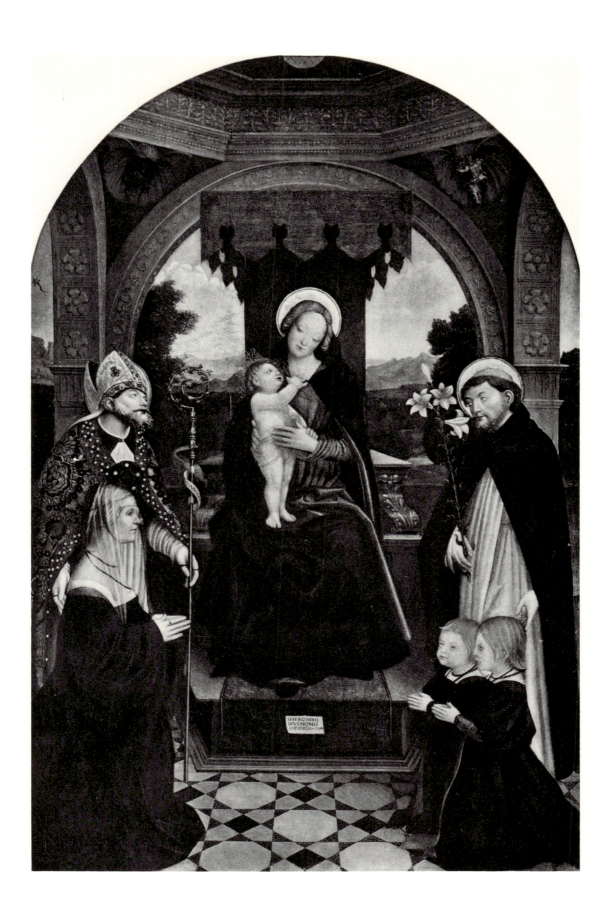

23
MACRINO D'ALBA
Deposition
PINACOTECA. TURIN
Photo Anderson

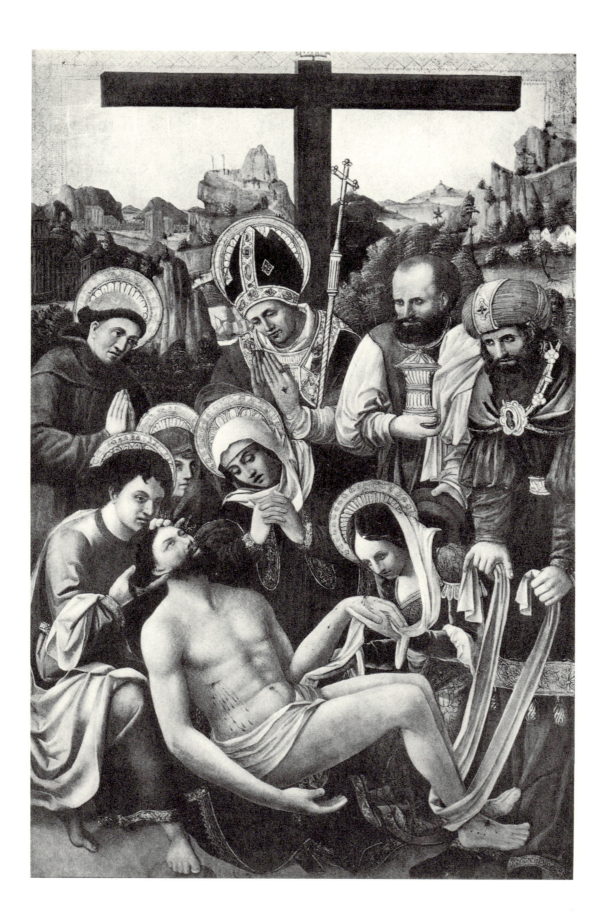

24

SODOMA

Vision of St. Catherine

SAN DOMENICO. SIENA

Photo Alinari

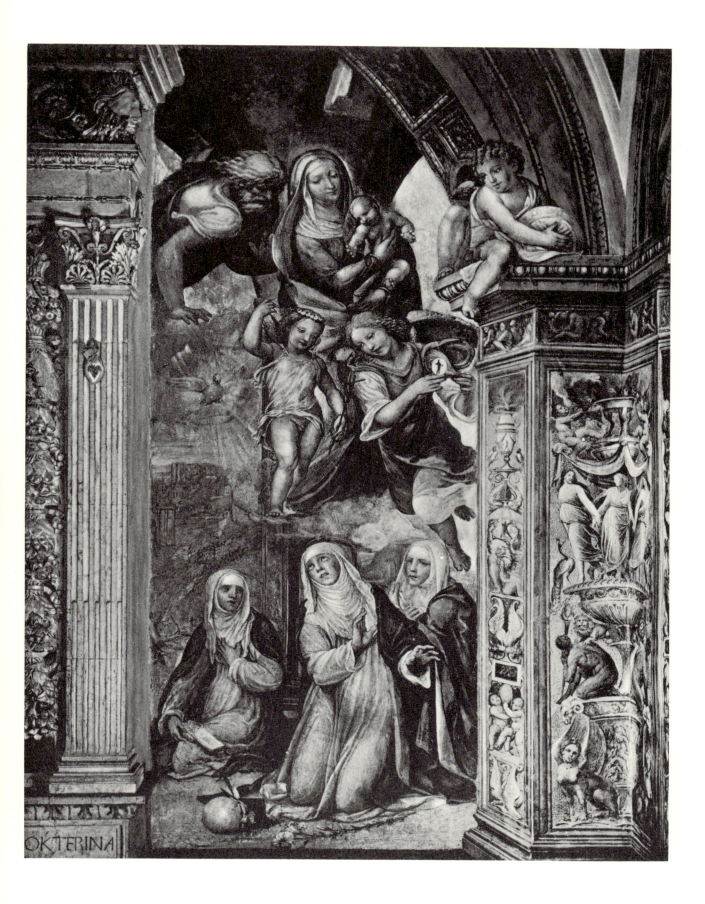

25

SODOMA
Vision of St. Catherine
SAN DOMENICO. SIENA
Photo Alinari

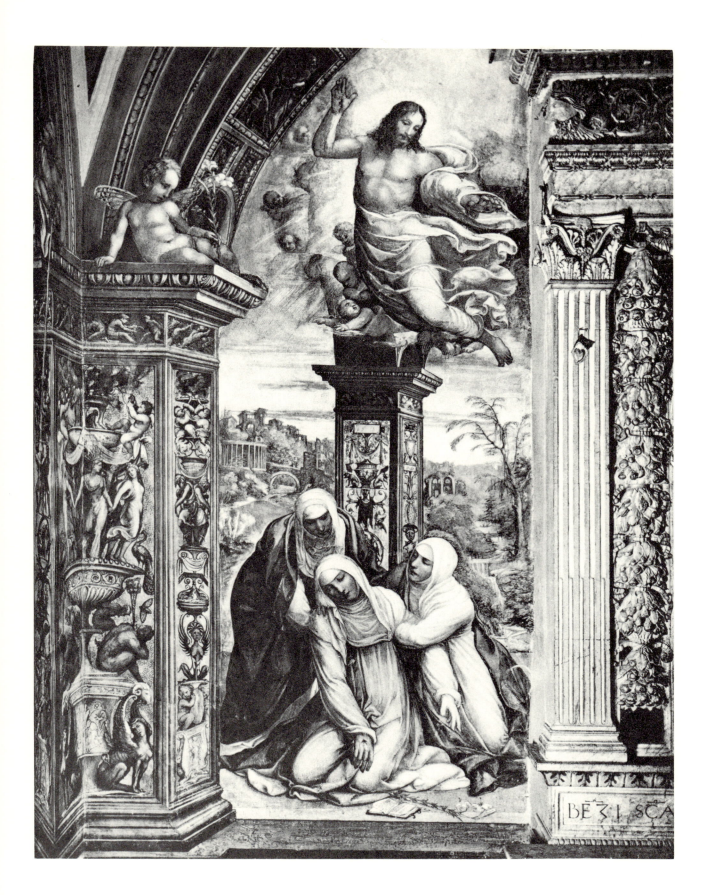

26

SODOMA
St. Sebastian
UFFIZI. FLORENCE
Photo Alinari

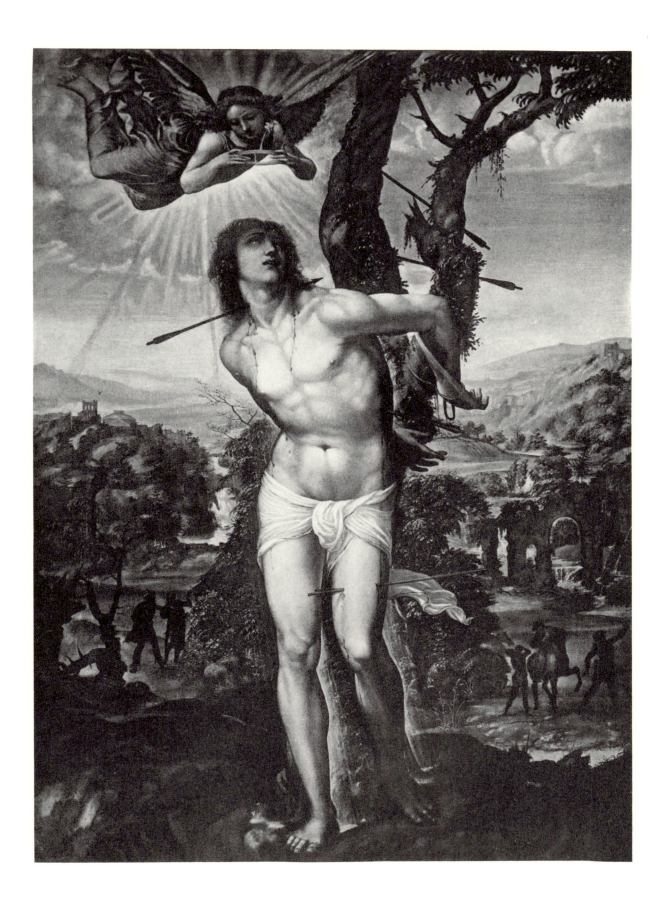

27

SODOMA
Marriage of Alexander and Roxana
FARNESINA. ROME
Photo Alinari

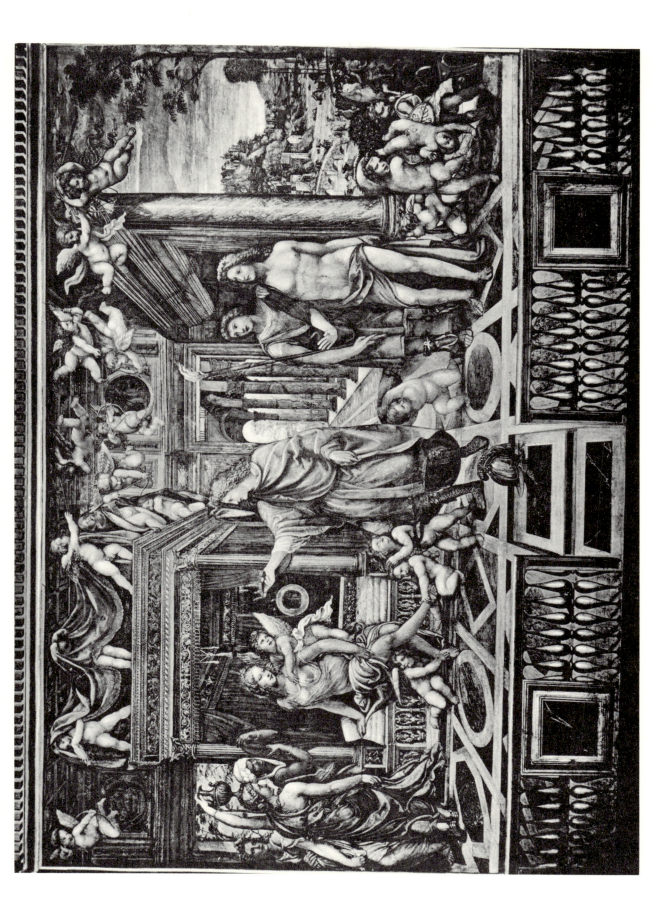

28

SODOMA

A. & B. Marriage of Alexander and Roxana. Details

FARNESINA. ROME

Photo Alinari

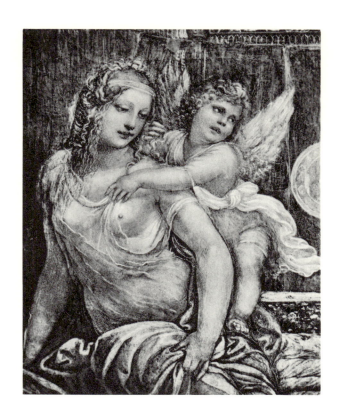

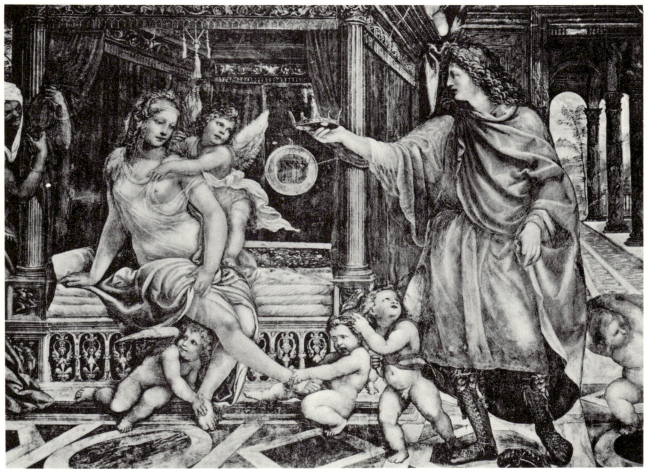

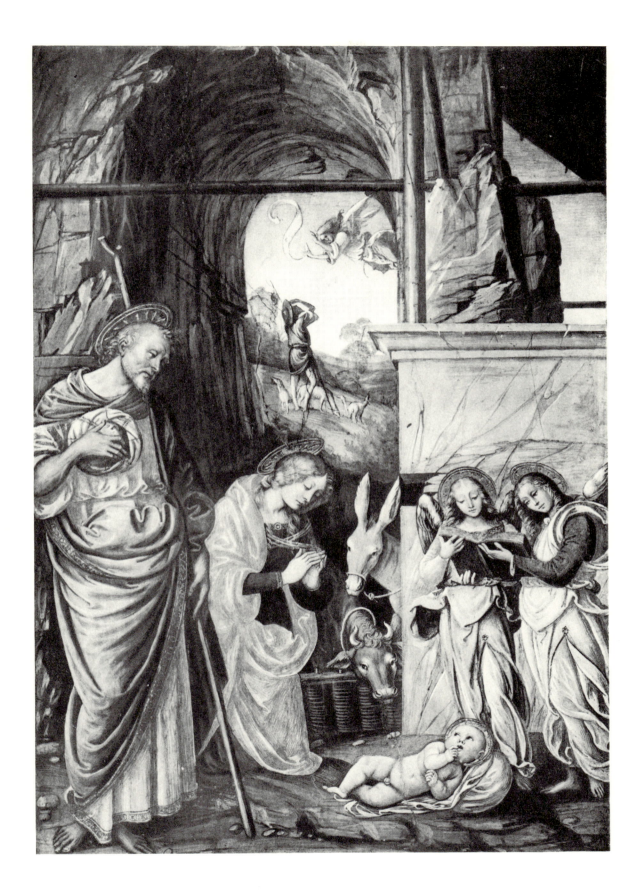

30

GAUDENZIO FERRARI

Madonna and Child

BRERA. MILAN

Photo Alinari

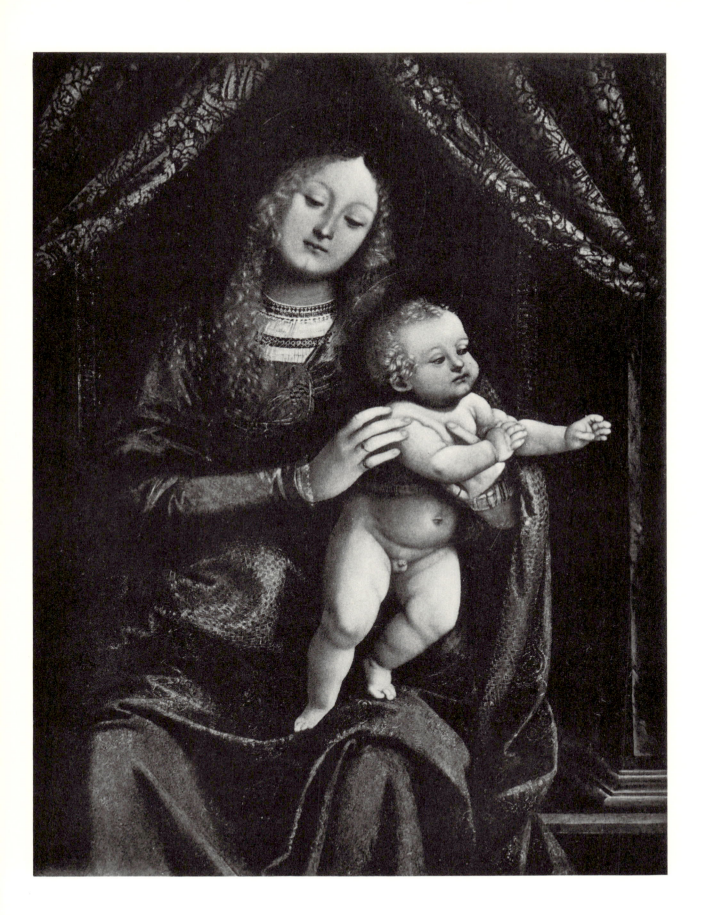

31
GAUDENZIO FERRARI
Crucifixion
SAN CRISTOFORO. VERCELLI
Photo Alinari

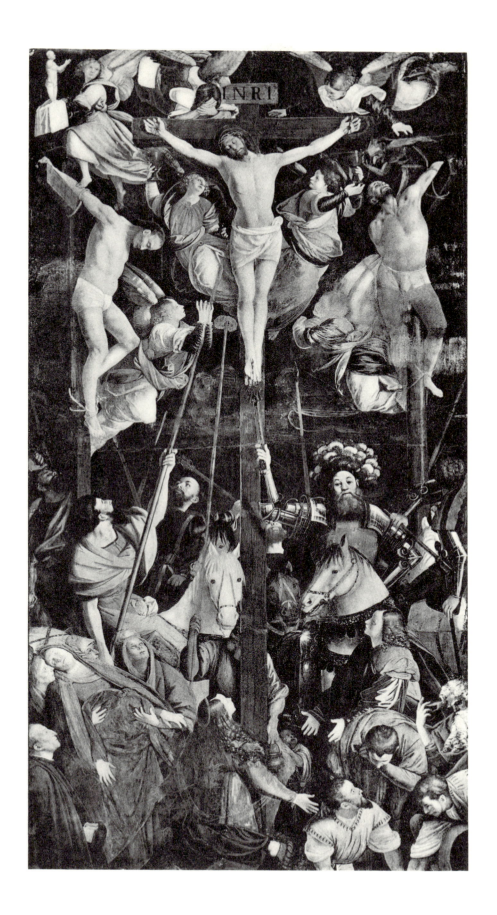

32

GAUDENZIO FERRARI
The Flight into Egypt
CATHEDRAL. COMO
Photo Alinari

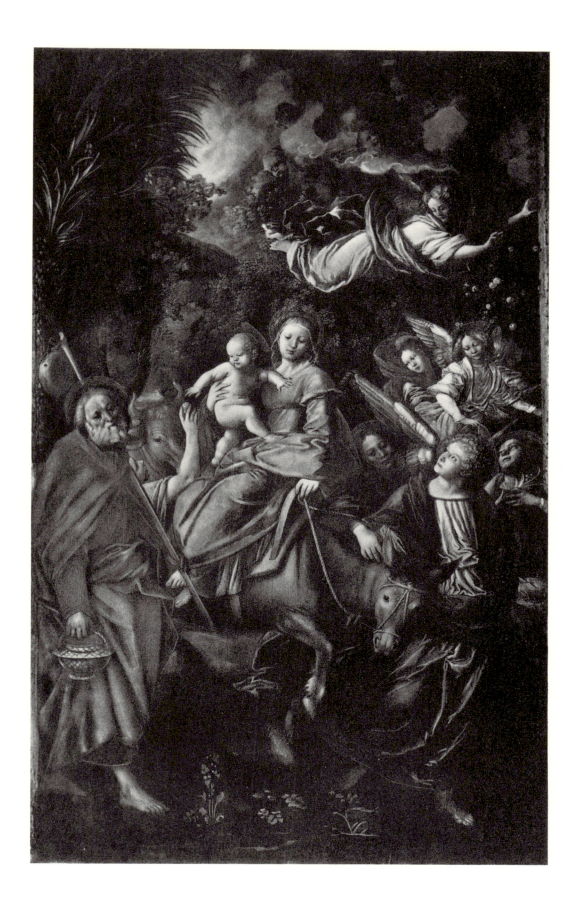

33
GAUDENZIO FERRARI
Baptism of the Prince of Marseilles
SAN CRISTOFORO. VERCELLI
Photo Alinari

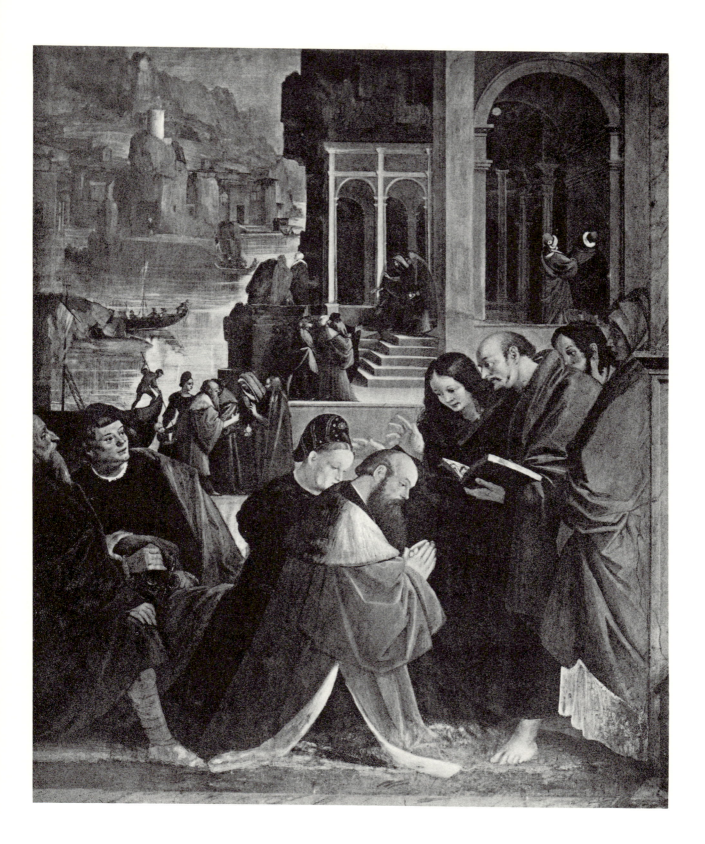

34
GAUDENZIO FERRARI
The Cupola
SARONNO
Photo Brogi

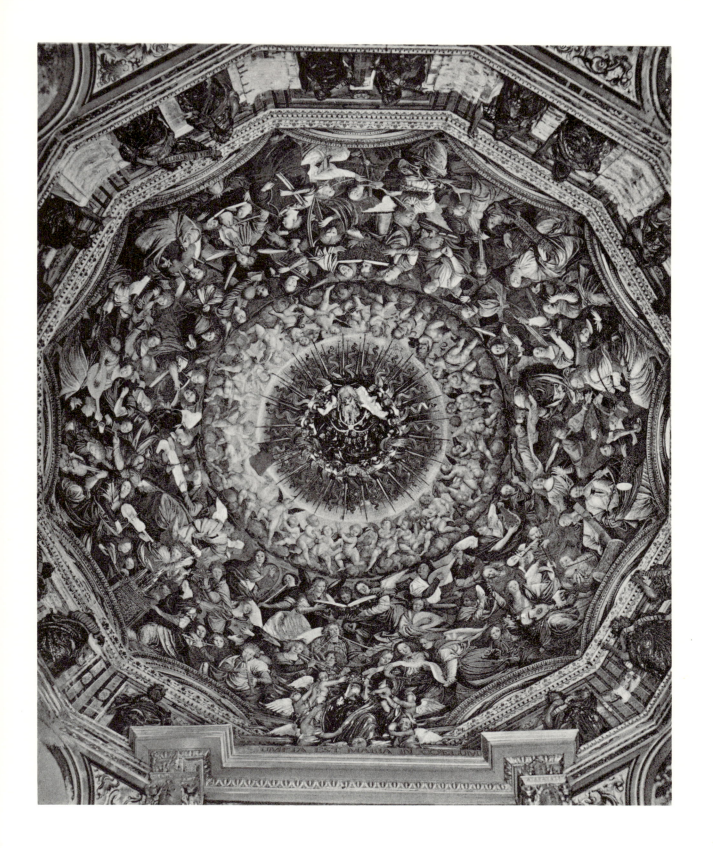

35
GAUDENZIO FERRARI
A. & B. Details from the Cupola
SARONNO
Photo Anderson

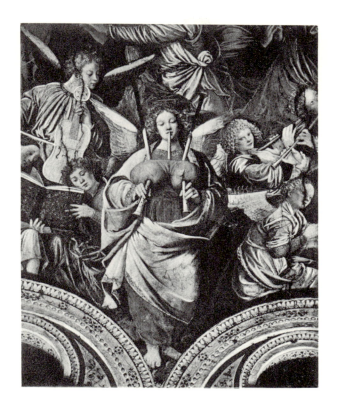

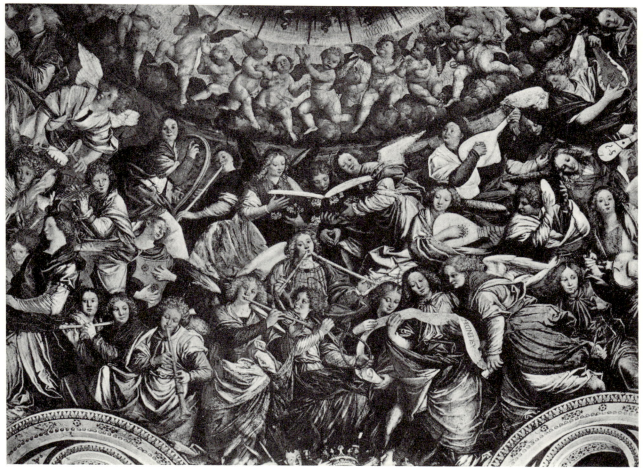

36

LANINO
Madonna and Child with Saints
PINACOTECA. TURIN

37

FIGINO

Portrait of Lucio Foppa

BRERA. MILAN

Photo Brogi

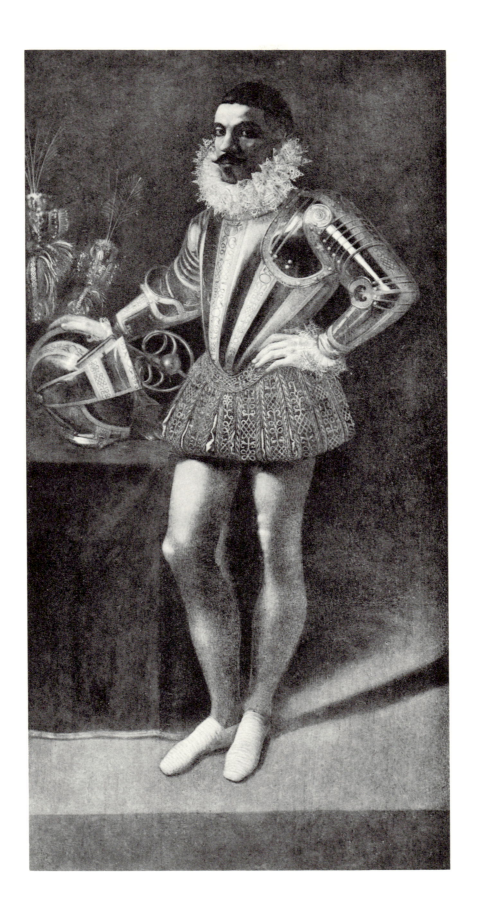

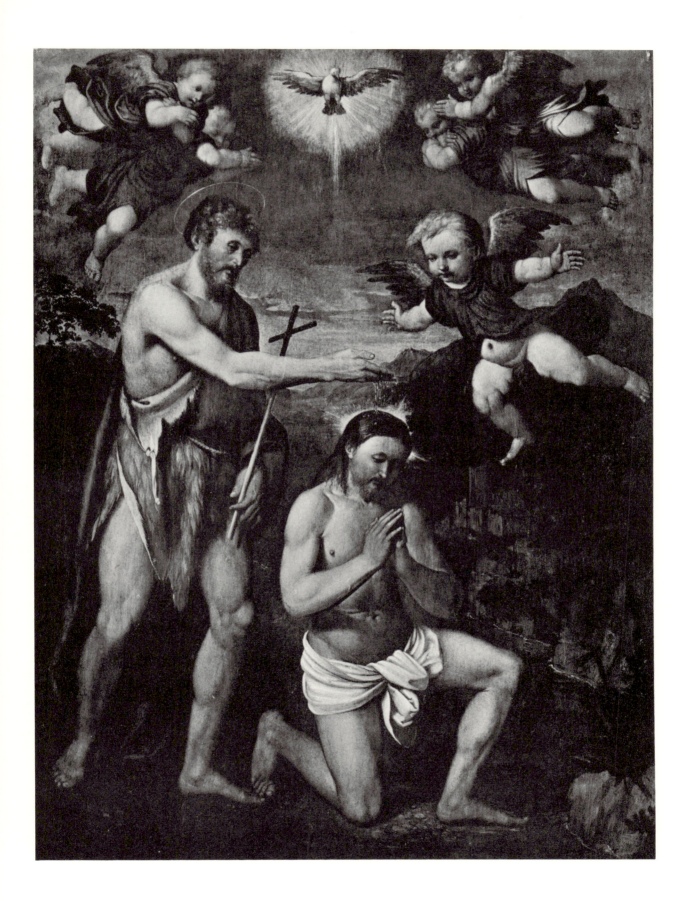

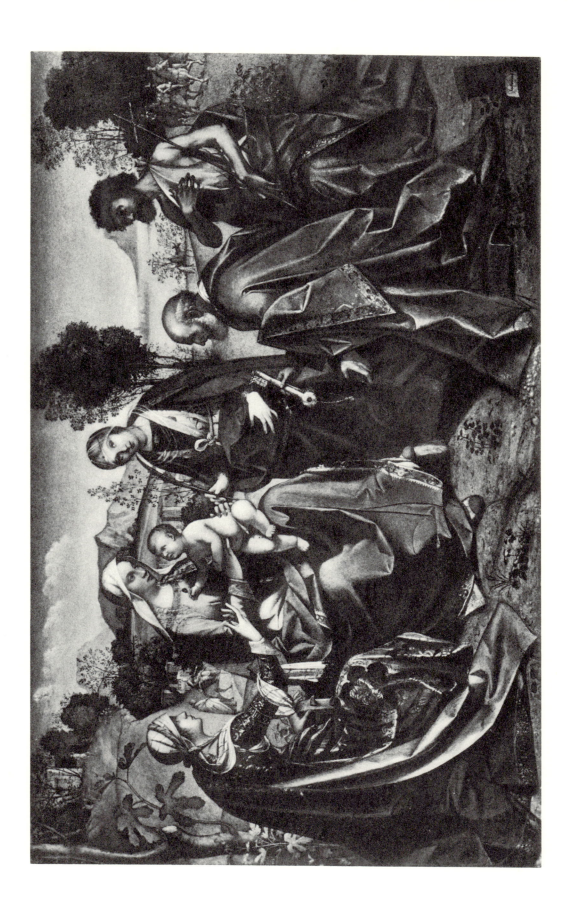

40

GIANFRANCESCO DEL BEMBO
Madonna with SS. Cosma and Damiano
SAN PIETRO. CREMONA

Photo Alinari

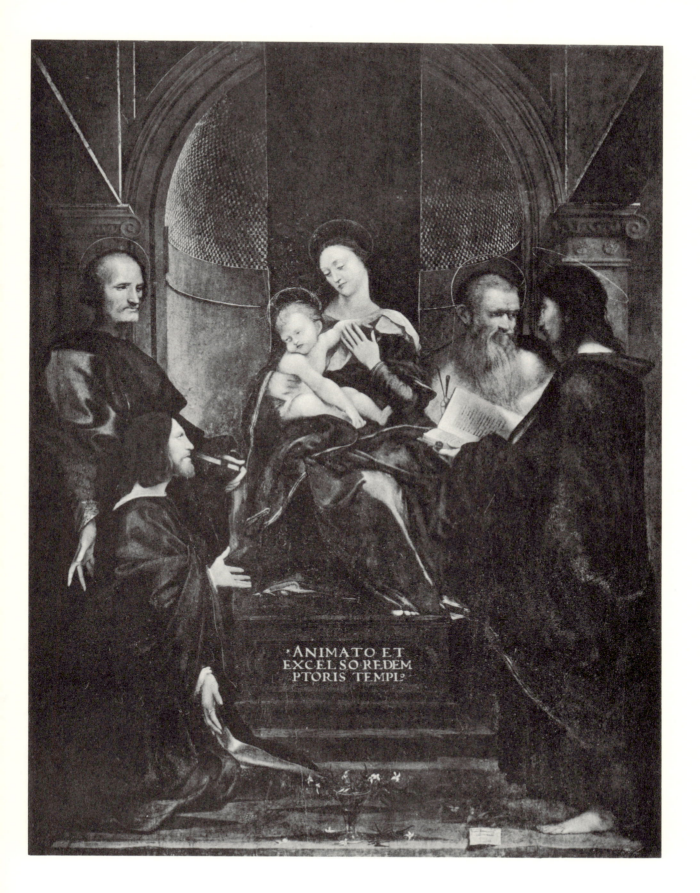

4I

CAMILLO BOCCACCINO
Madonna and Saints
BRERA. MILAN
Photo Alinari

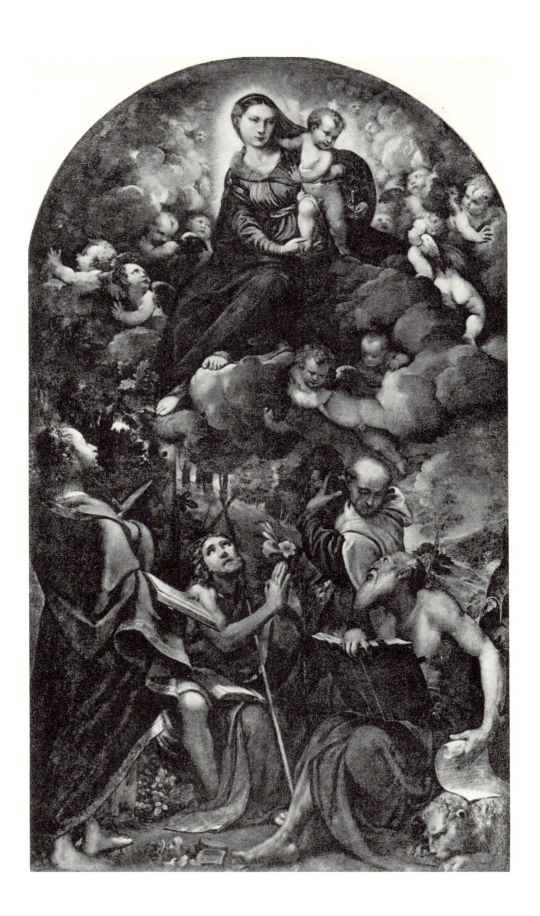

42

GIULIO CAMPI
Christ among the Doctors
STA. MARGHERITA. CREMONA
Photo Alinari

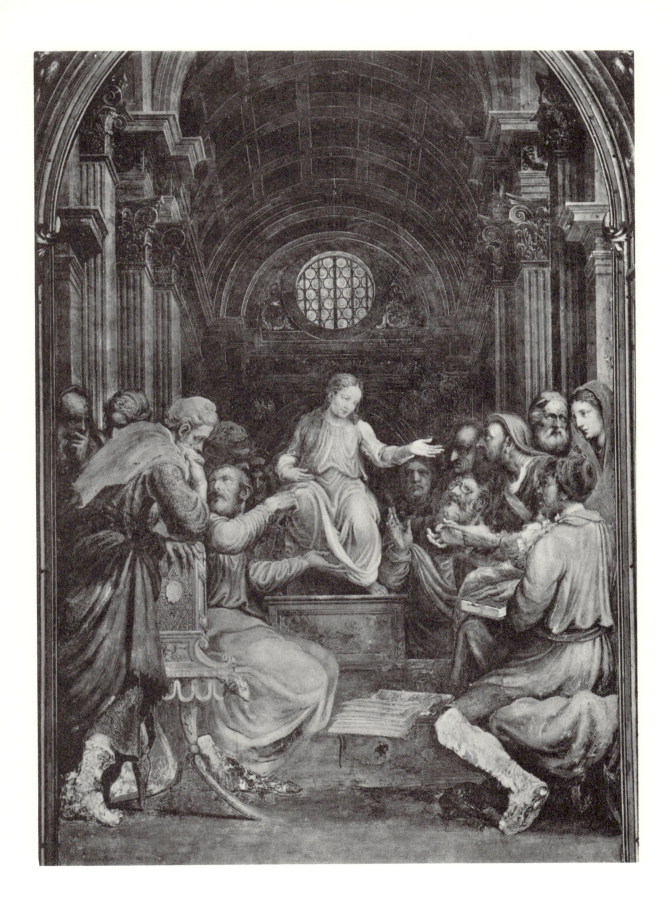

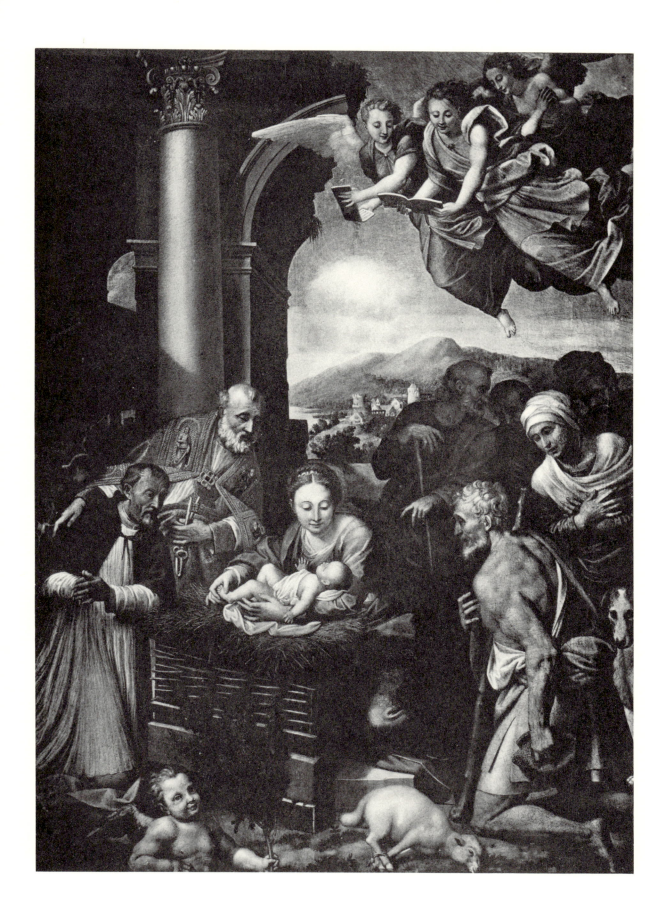

44

SOFONISBA ANGUISSOLA
Portrait of the Doctor Piermaria of Cremona
PRADO. MADRID

Photo Anderson

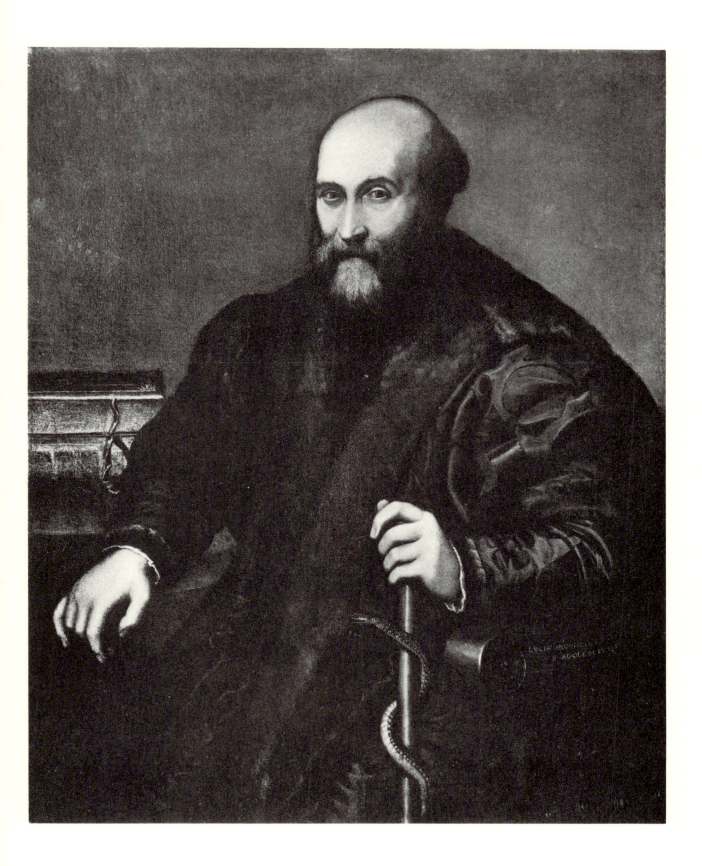

45

LUCA CAMBIASO
Presentation in the Temple
SAN LORENZO. GENOA
Photo Noack

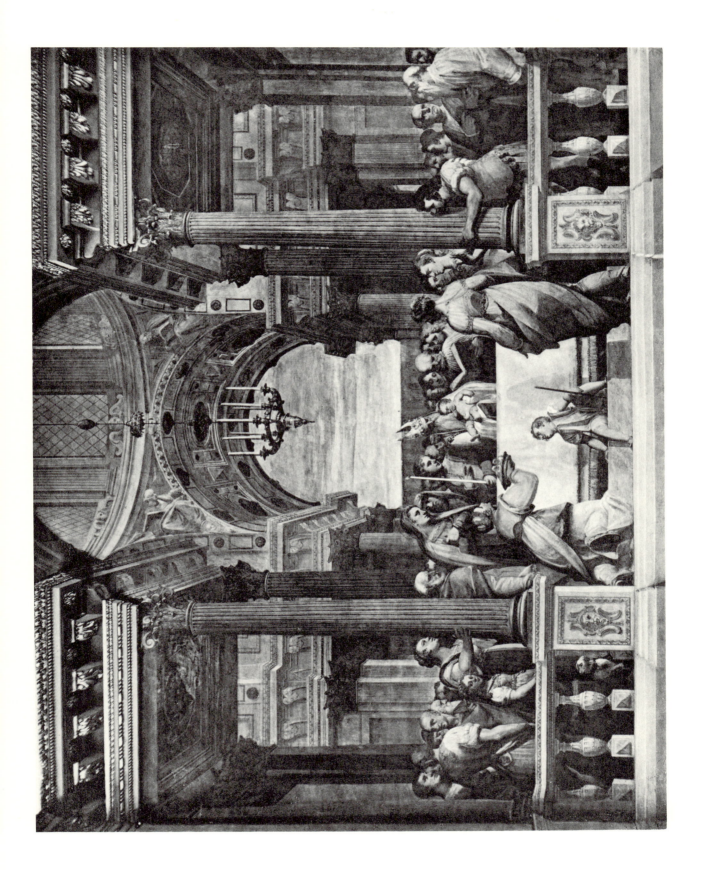

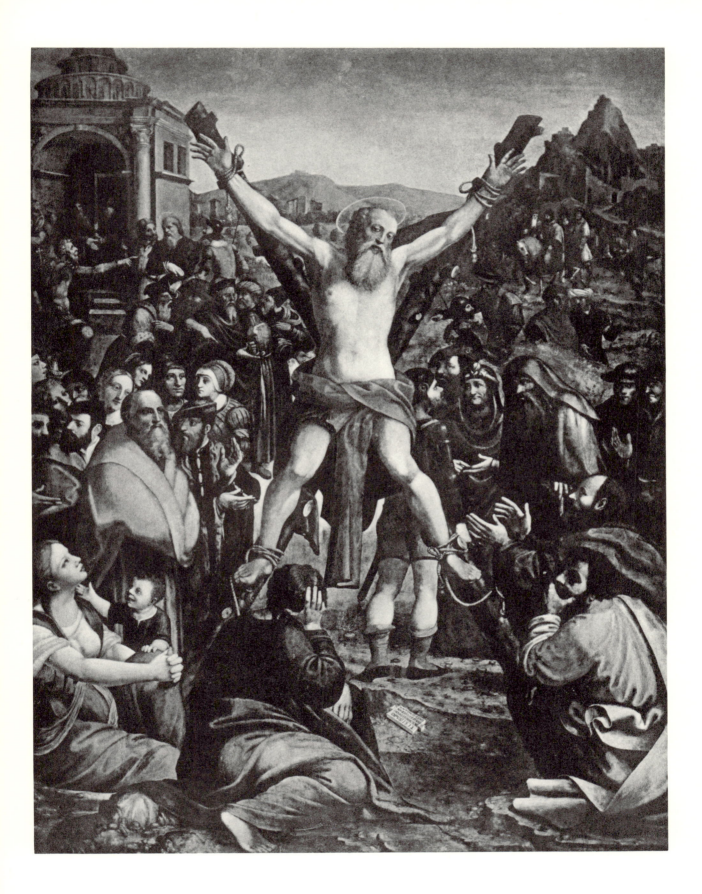

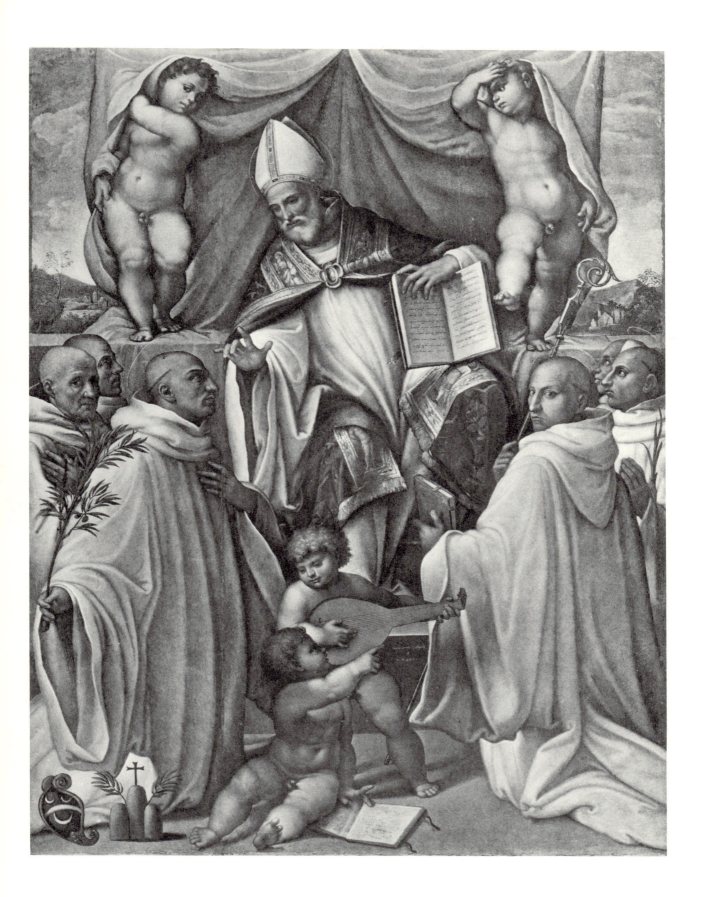

48

BAGNACAVALLO

Circumcision

LOUVRE. PARIS

Photo Alinari

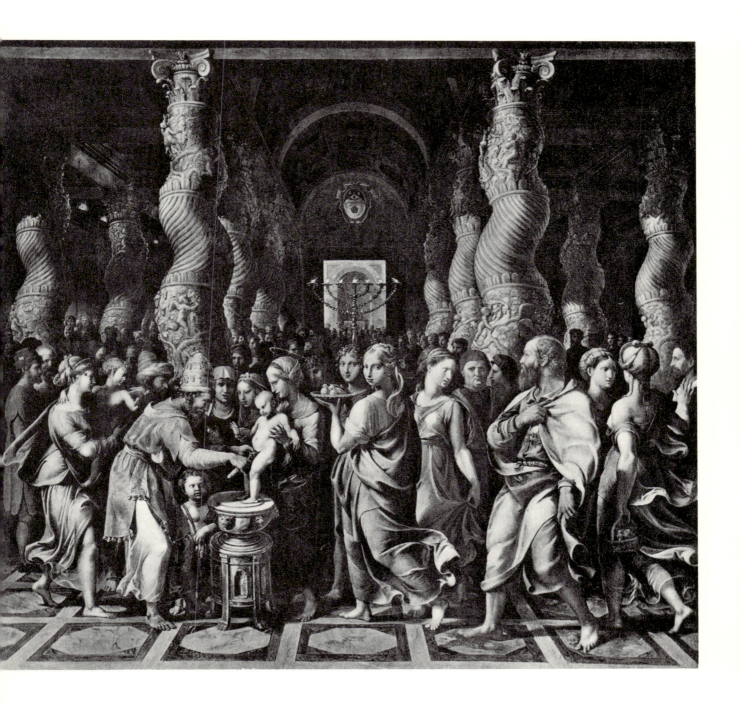

49

INNOCENZO DA IMOLA
Marriage of St. Catherine
SAN GIACOMO. BOLOGNA

Photo Alinari

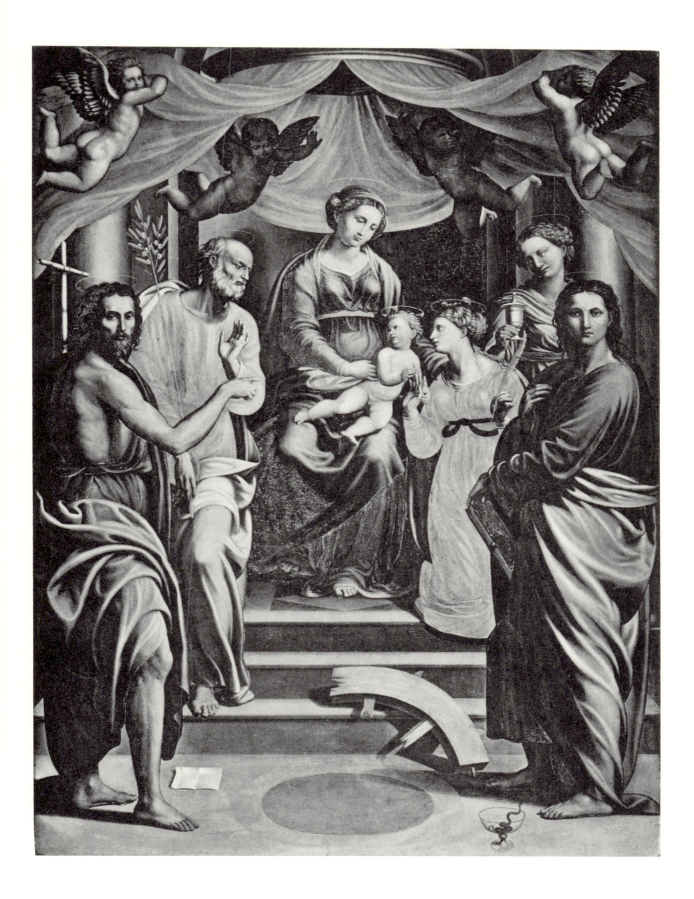

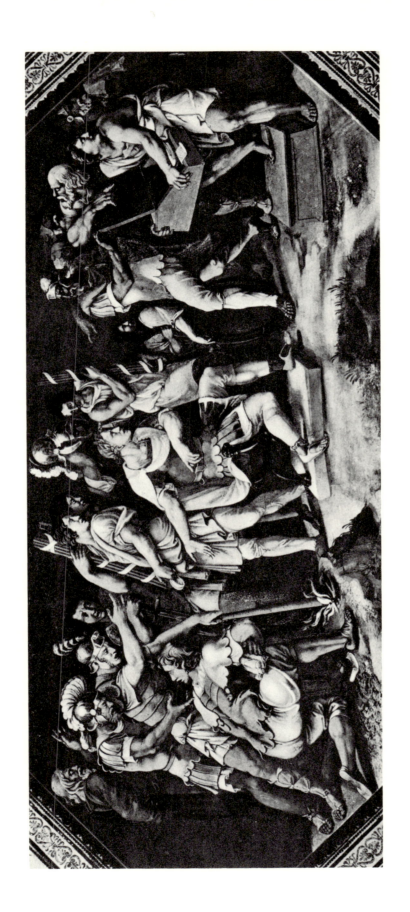

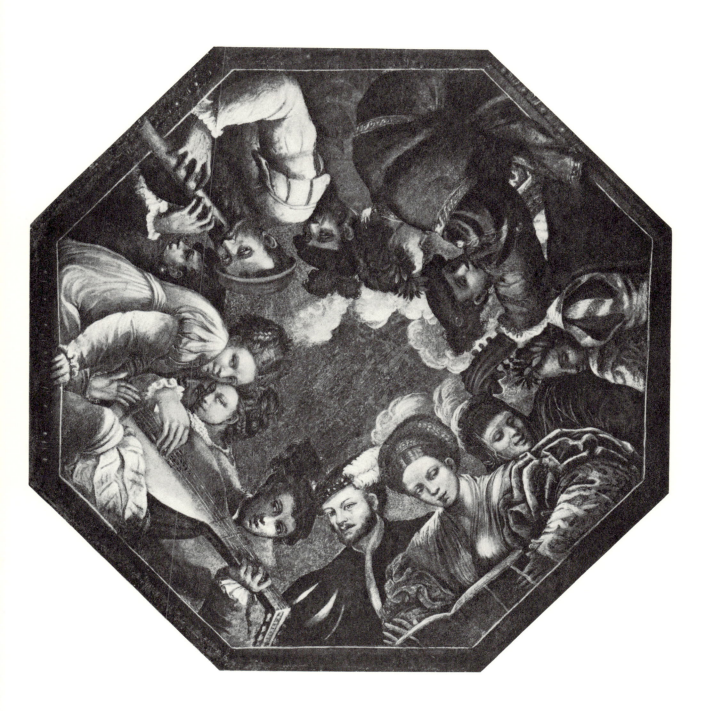

52

BARTOLOMEO PASSAROTTI
Madonna and Saints
San Giacomo. Bologna
Photo Alinari

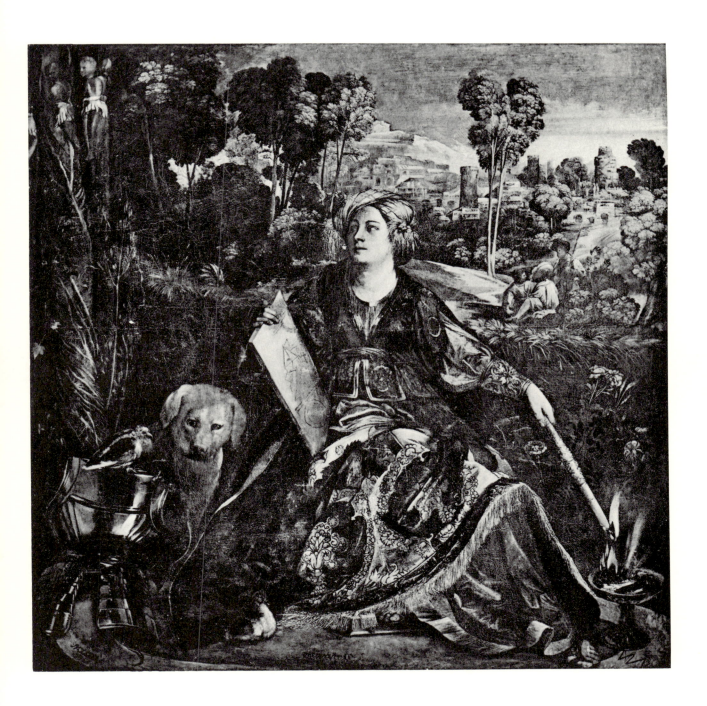

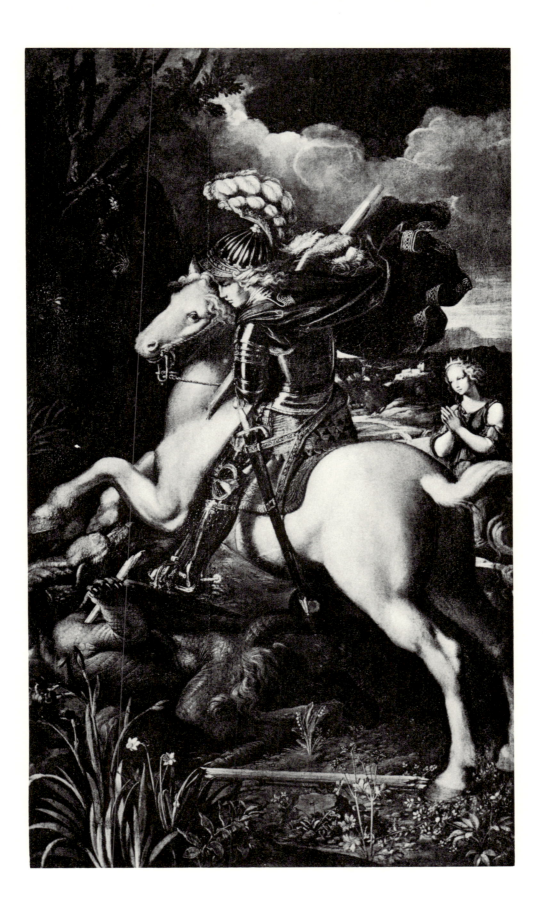

55
BATTISTA LUTERI (DOSSI)
Madonna and Child
GALLERIA BORGHESE. ROME
Photo Brogi

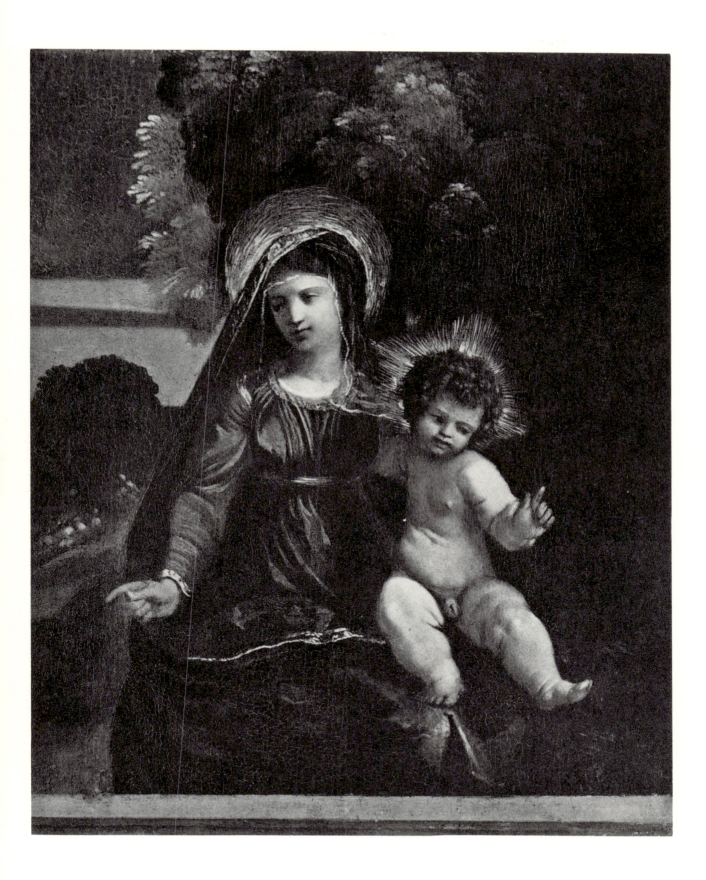

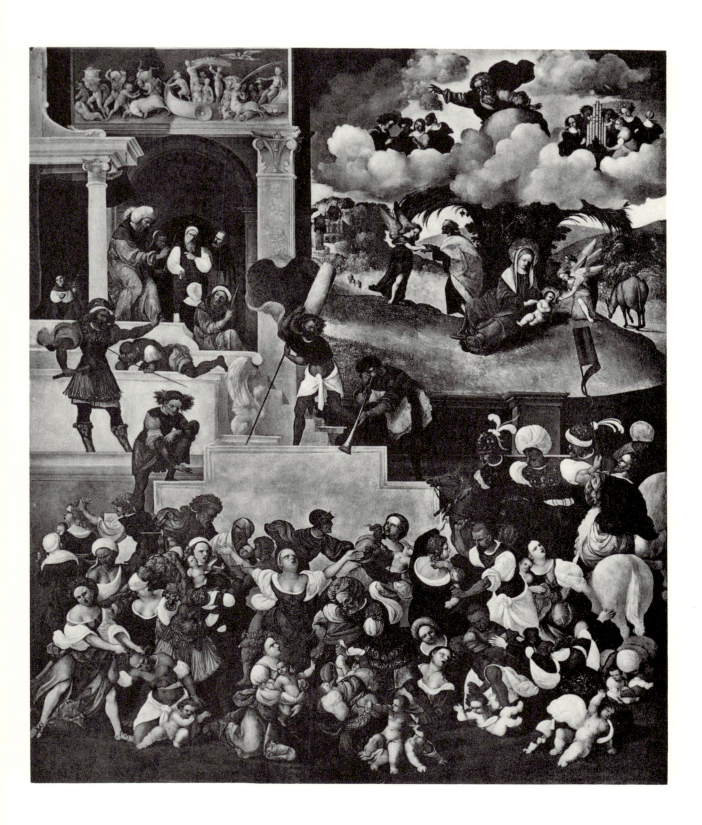

57

ASPERTINI
Baptism of St. Augustine
SAN FREDIANO. LUCCA
Photo Alinari

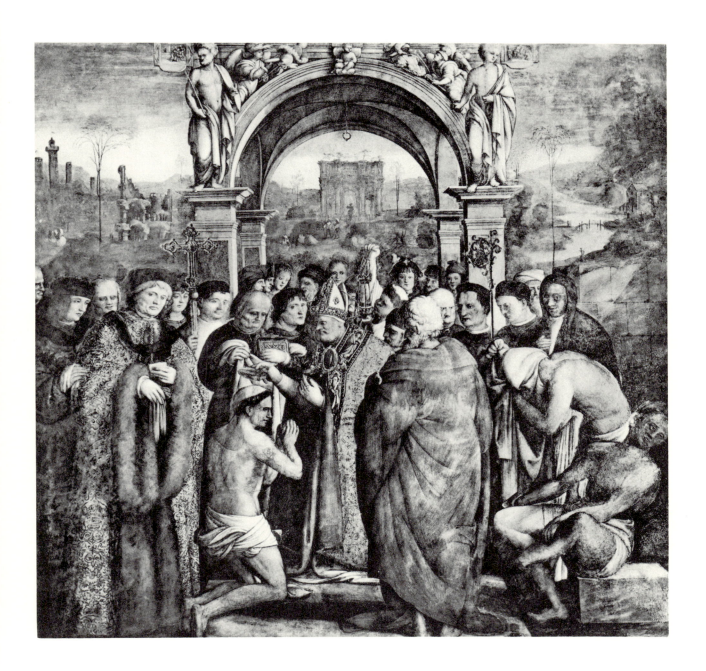

58

GAROFALO
Virgin and Saints
GALLERIA. MODENA
Photo Alinari

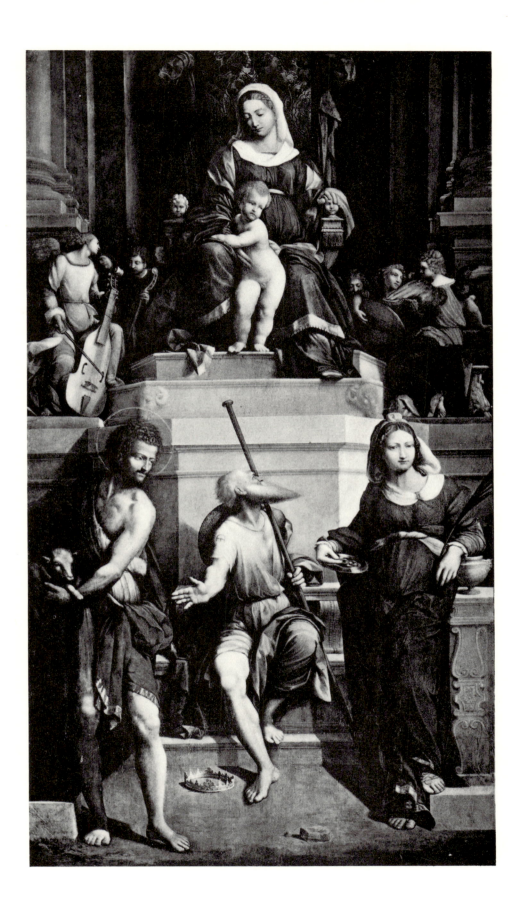

59

GIROLAMO DA CARPI
Miracle of St. Anthony
PINACOTECA. FERRARA

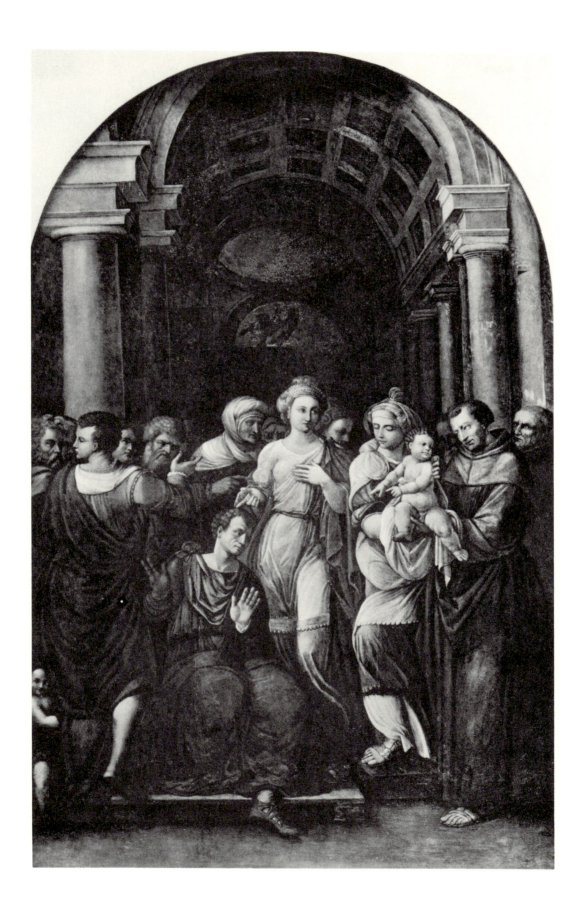

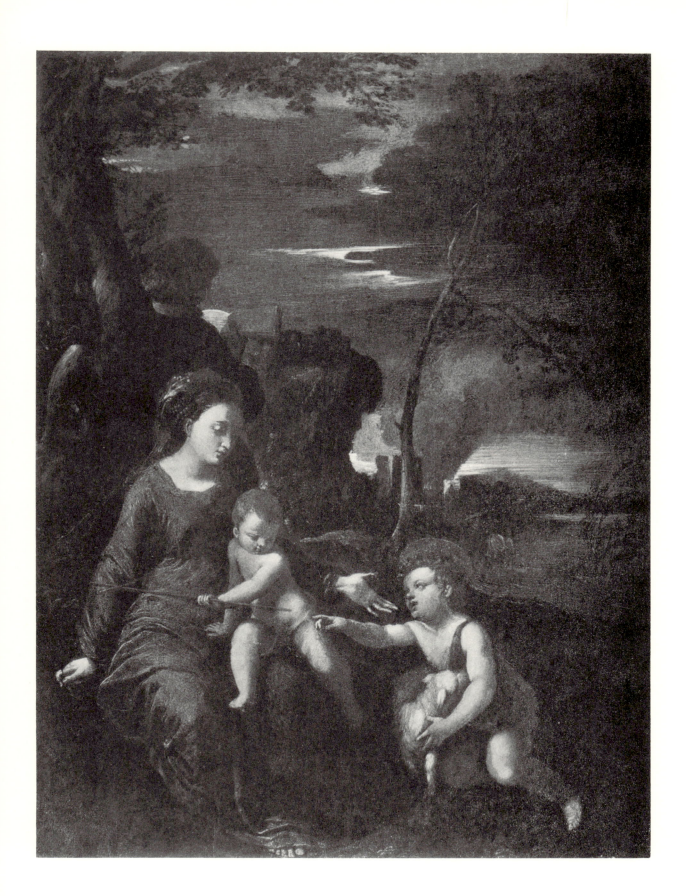

61

CORREGGIO
One side of the Camera di San Paolo
PARMA
Photo Alinari

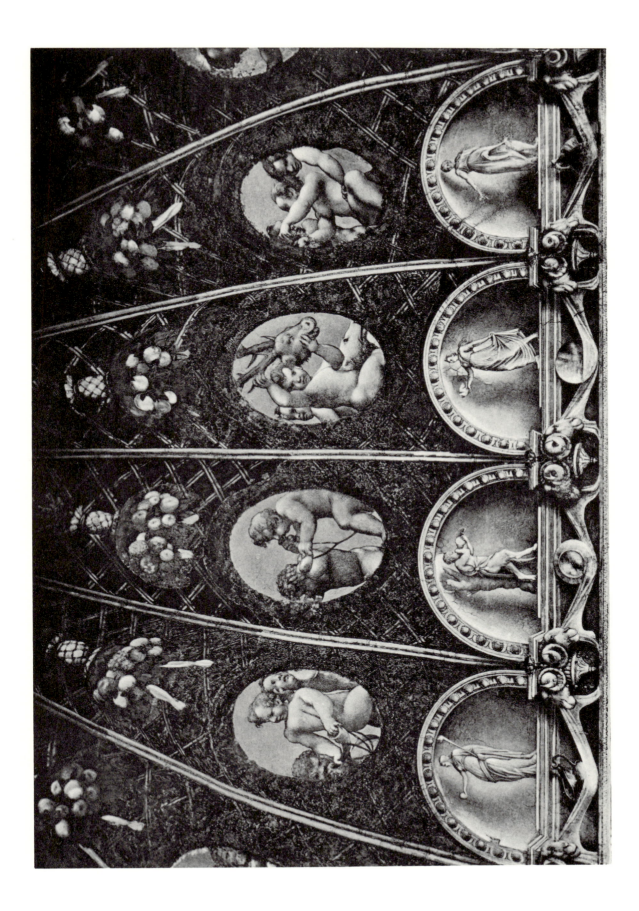

62

CORREGGIO
A. & B. Cupola
San Giovanni. Parma
Photo Anderson

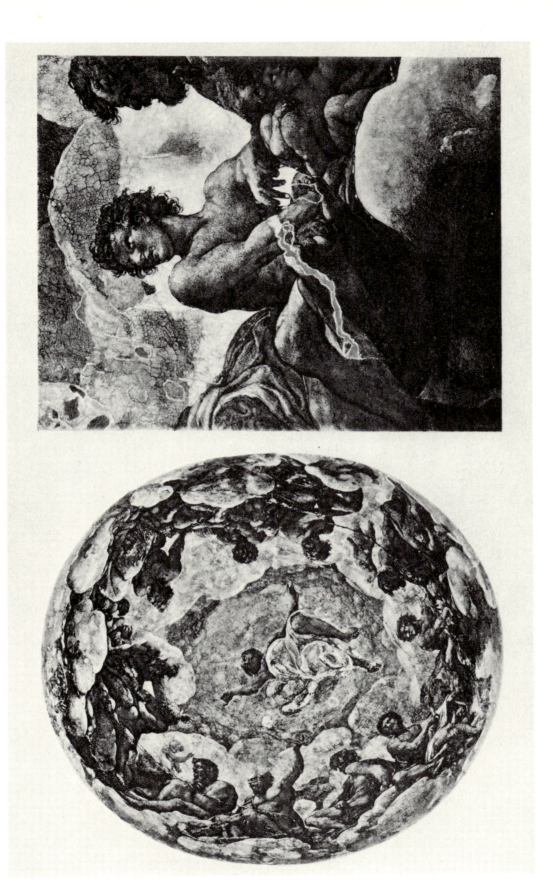

63

CORREGGIO

Lunette

San Giovanni. Parma

Photo Anderson

64

CORREGGIO
Madonna della Scodella
PARMA
Photo Alinari

65

CORREGGIO
Madonna del San Girolamo
PARMA
Photo Anderson

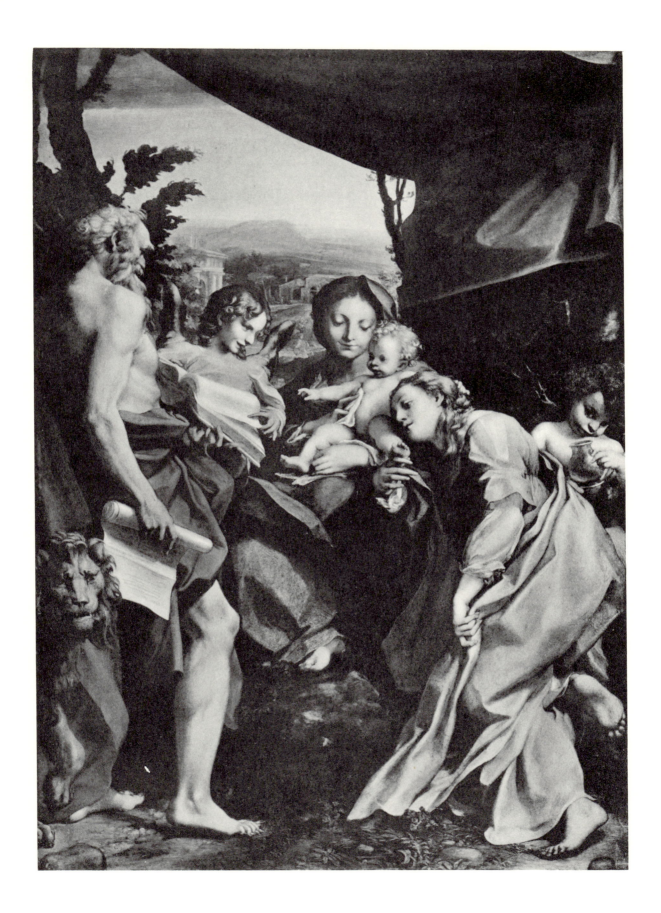

66

CORREGGIO
« Night »
GALLERY. DRESDEN
Photo Alinari

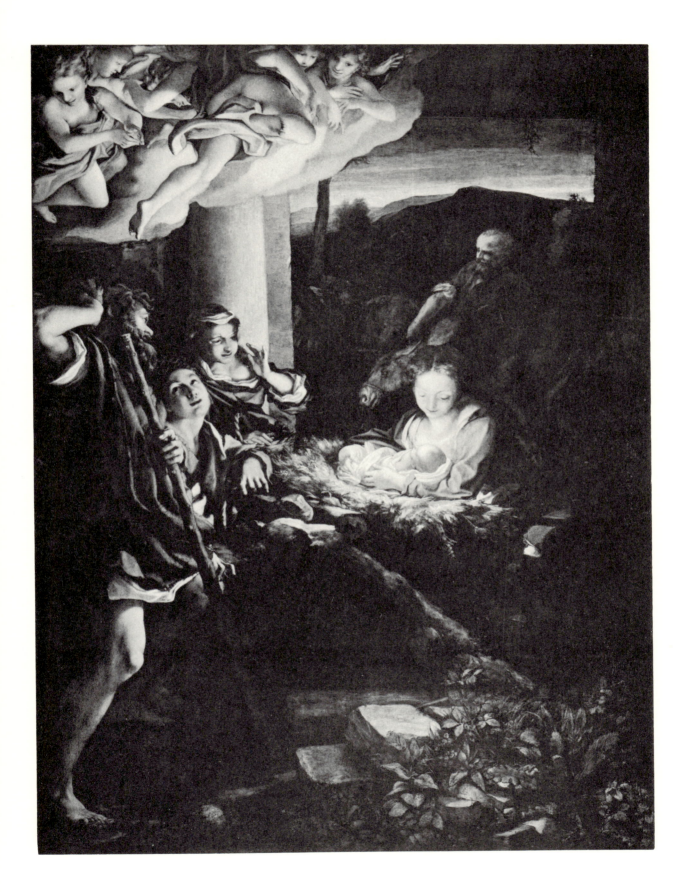

67
CORREGGIO
Cupola. Detail
CATHEDRAL. PARMA

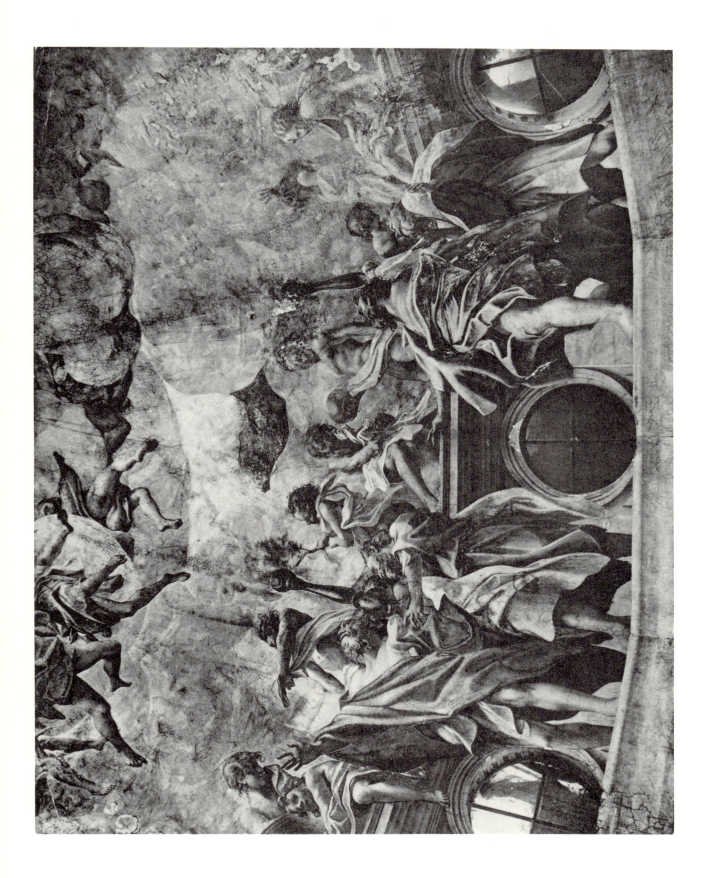

68

CORREGGIO
A. & B. Cupola. Details
CATHEDRAL. PARMA

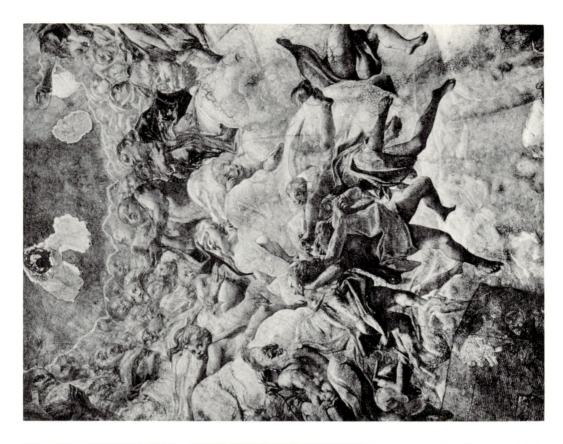

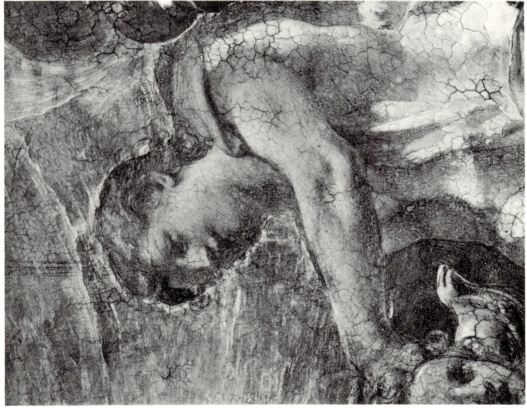

69

CORREGGIO
A. & B. Cupola. Details
CATHEDRAL. PARMA

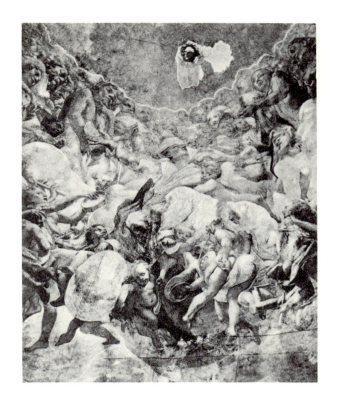

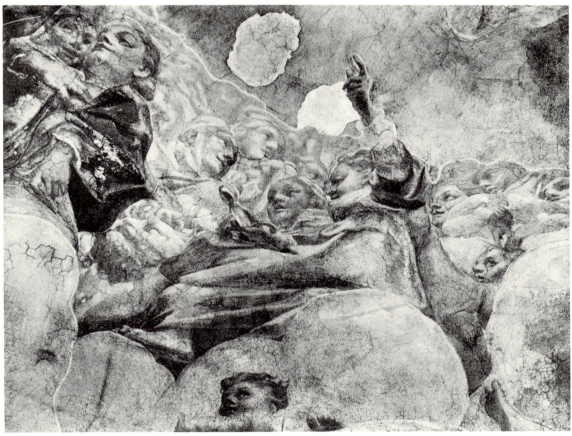

70

CORREGGIO

Antiope

Louvre. Paris

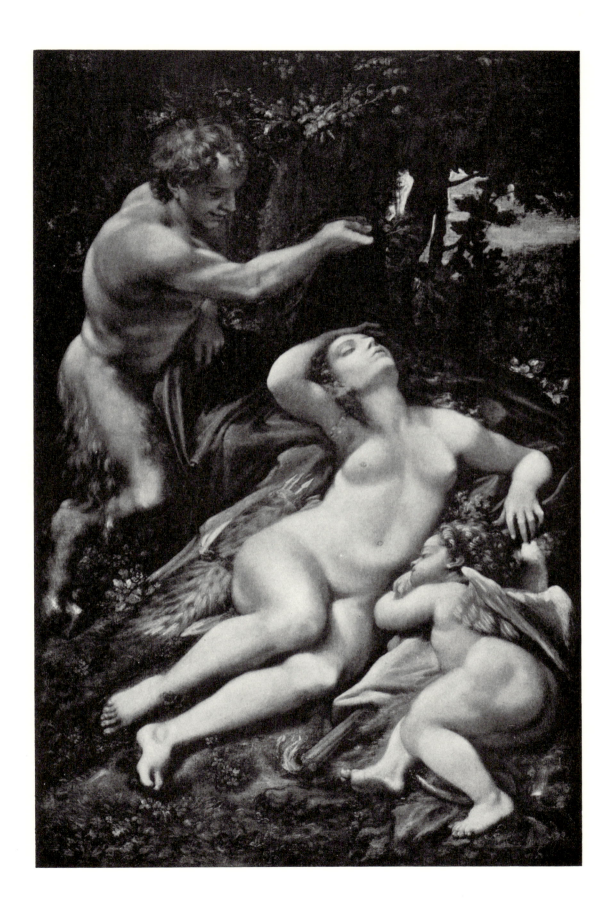

71
CORREGGIO
Io
BELVEDERE. VIENNA
Photo Hanfstaengl

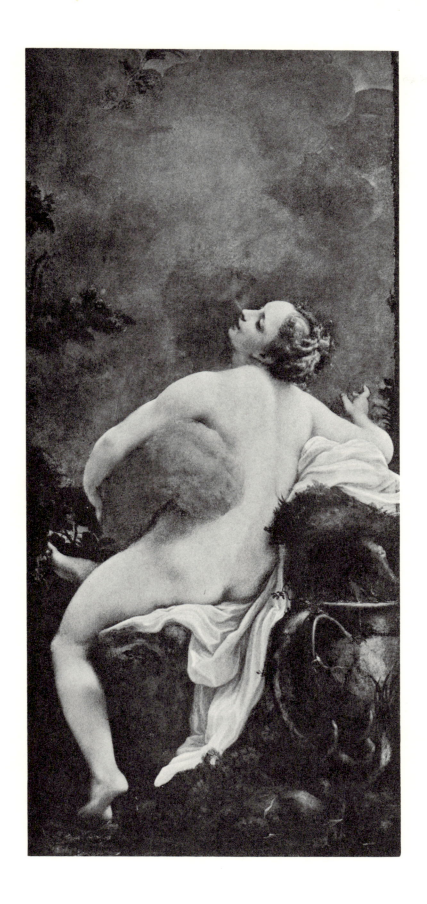

72

CORREGGIO

Danae

GALLERIA BORGHESE. ROME

Photo Brogi

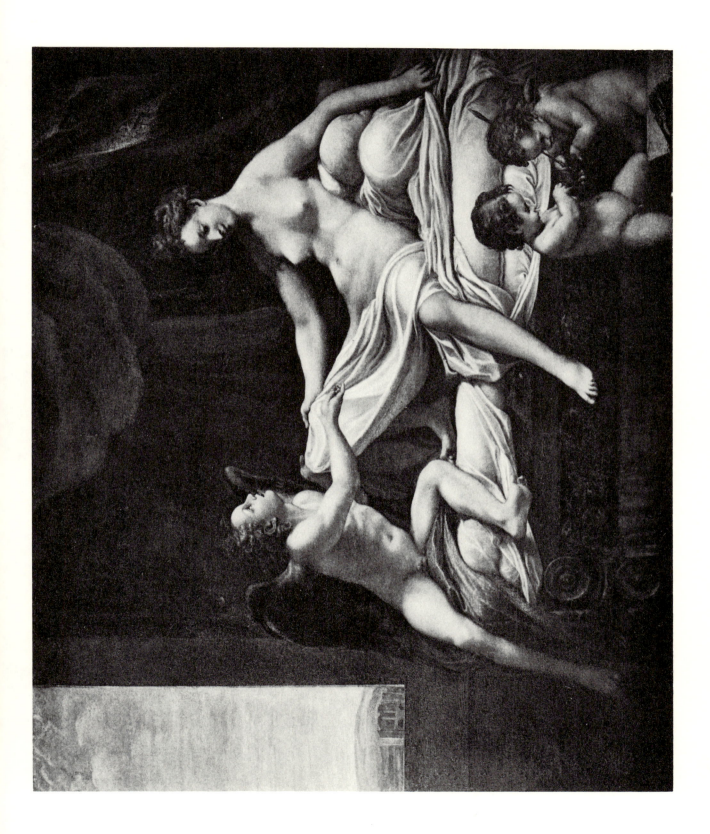

73
CORREGGIO
Ganymede
BELVEDERE. VIENNA
Photo Hanfstaengl

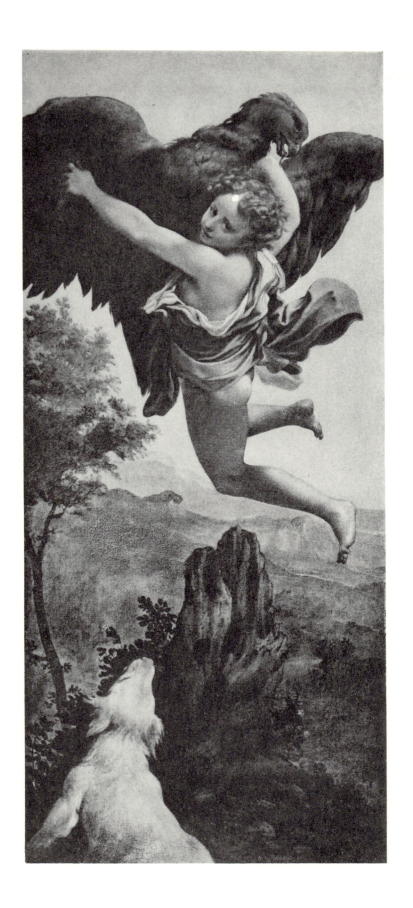

74

GANDINO DEL GRANO

Madonna and Saints

GALLERIA. PARMA

Photo Alinari

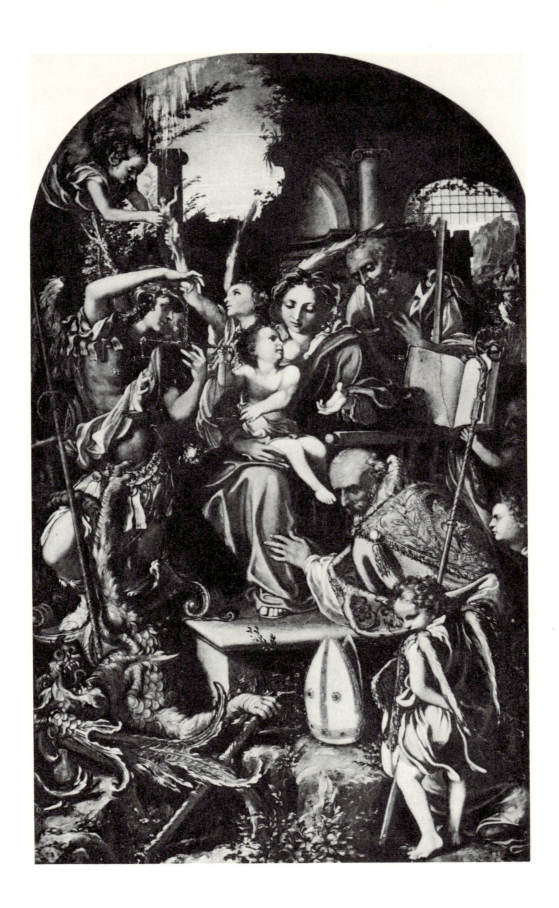

75
RONDANI
Madonna and Saints
GALLERIA. PARMA
Photo Anderson

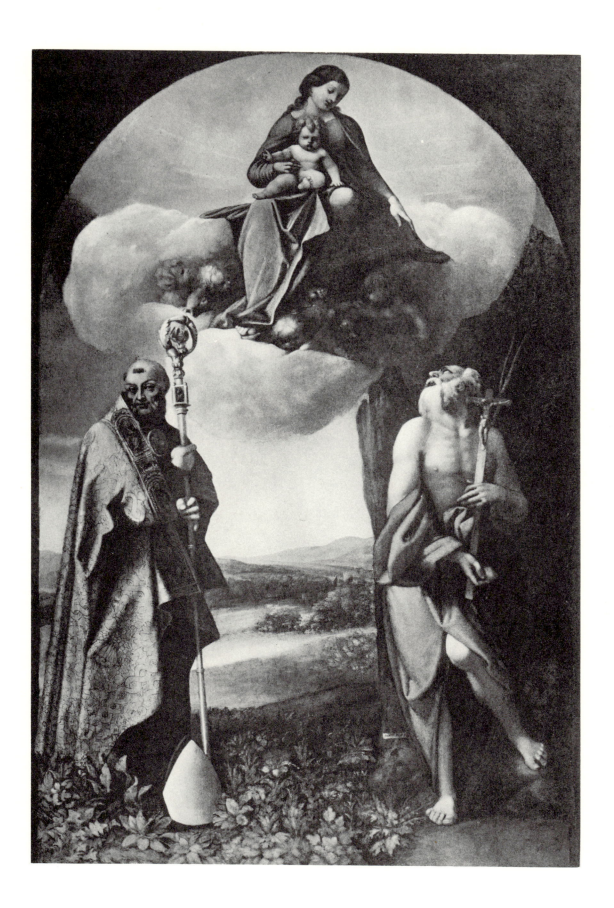

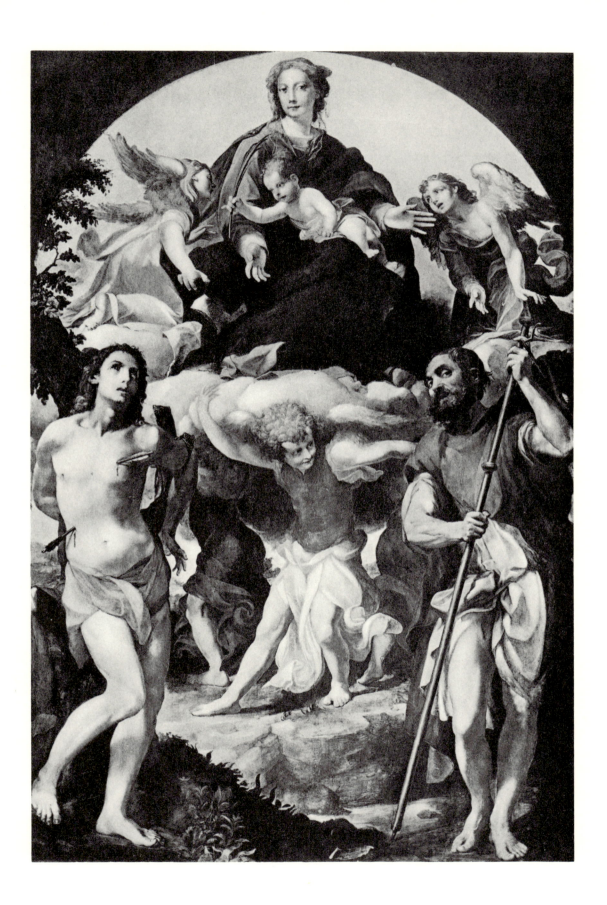

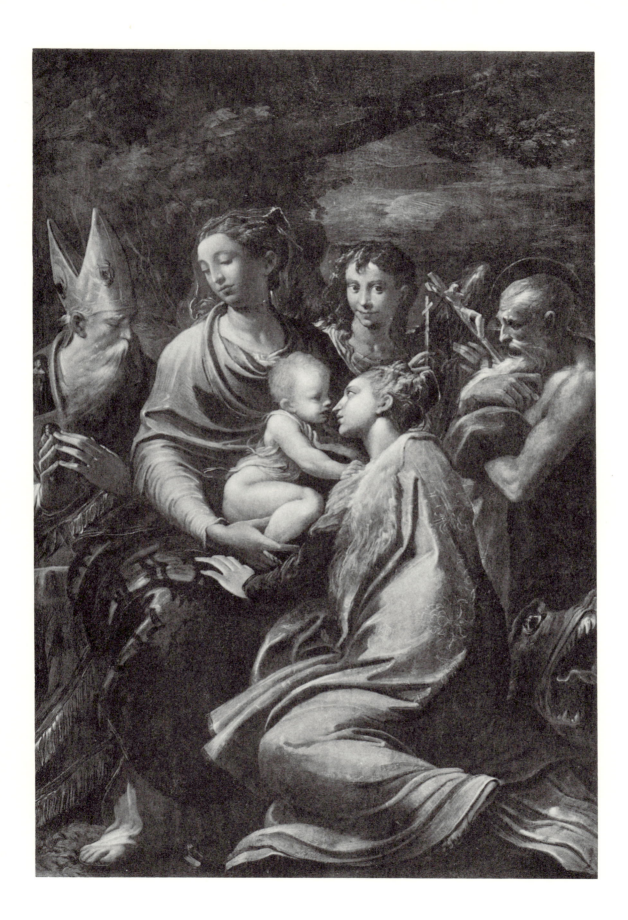

78

PARMIGIANINO
Portrait of Anthaea
MUSEUM. NAPLES
Photo Alinari

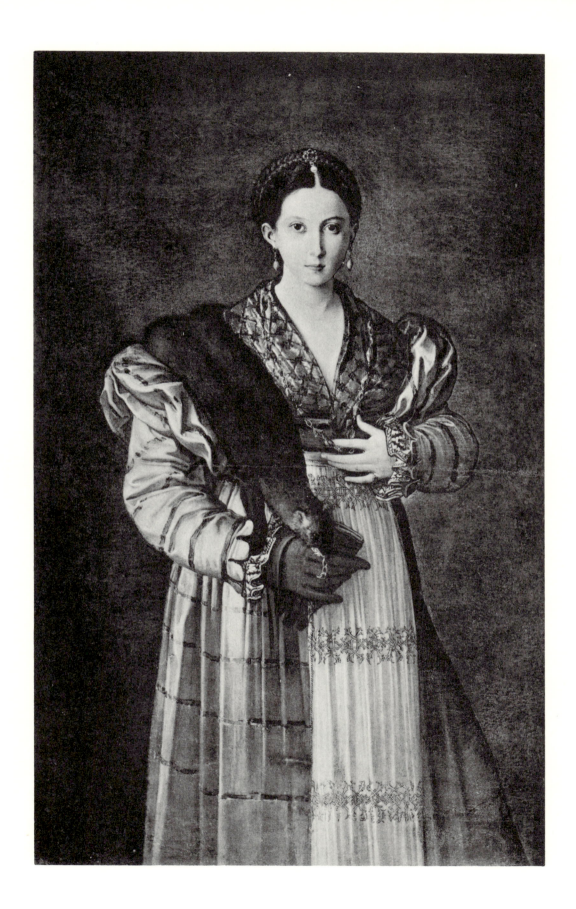

79
MAZZOLA BEDOLI
A. Conception
B. Conception. Detail
GALLERIA. PARMA
Photo Alinari

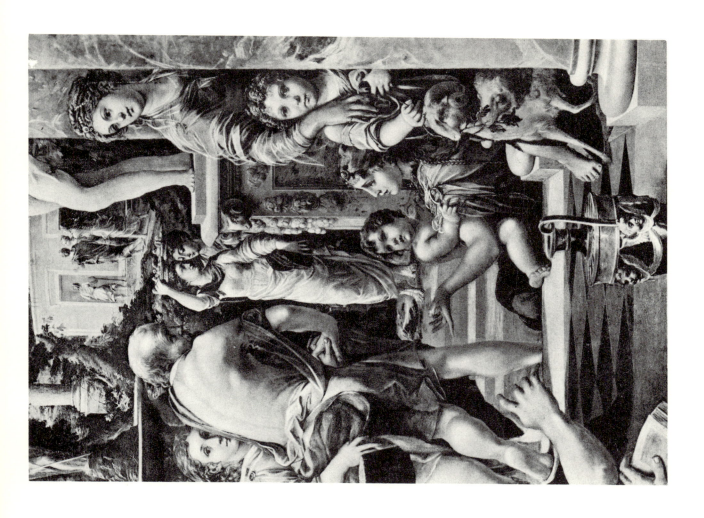

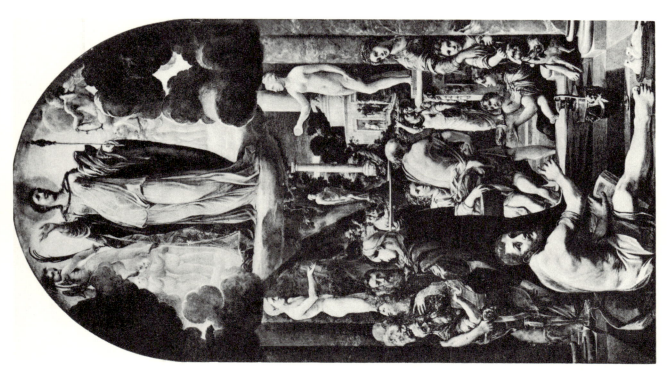

80

POMPONIO ALLEGRI

Charity

GALLERIA. RAVENNA

Photo Alinari

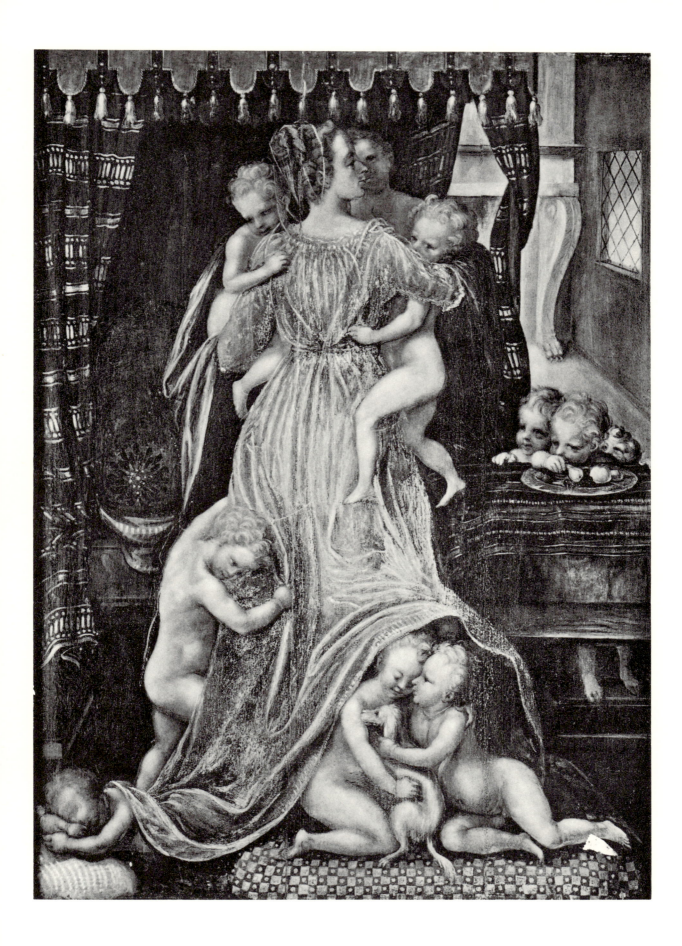

81

LUCA LONGHI
The Marriage in Cana. Detail
REFETTORIO DI CLASSE. RAVENNA
Photo Alinari

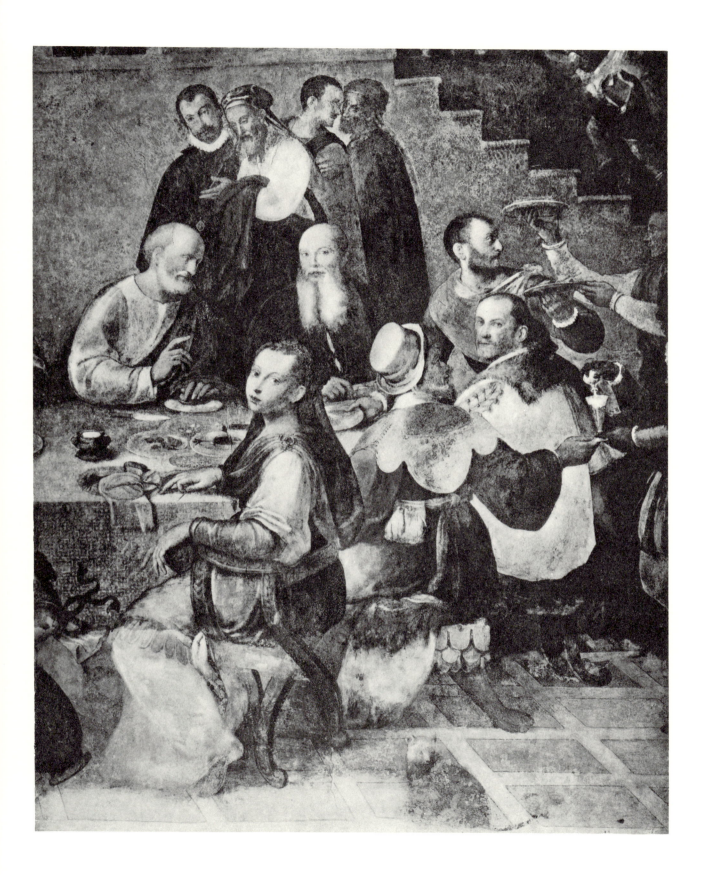

82

SABBATINI
Assumption of the Virgin
PINACOTECA. BOLOGNA
Photo Alinari

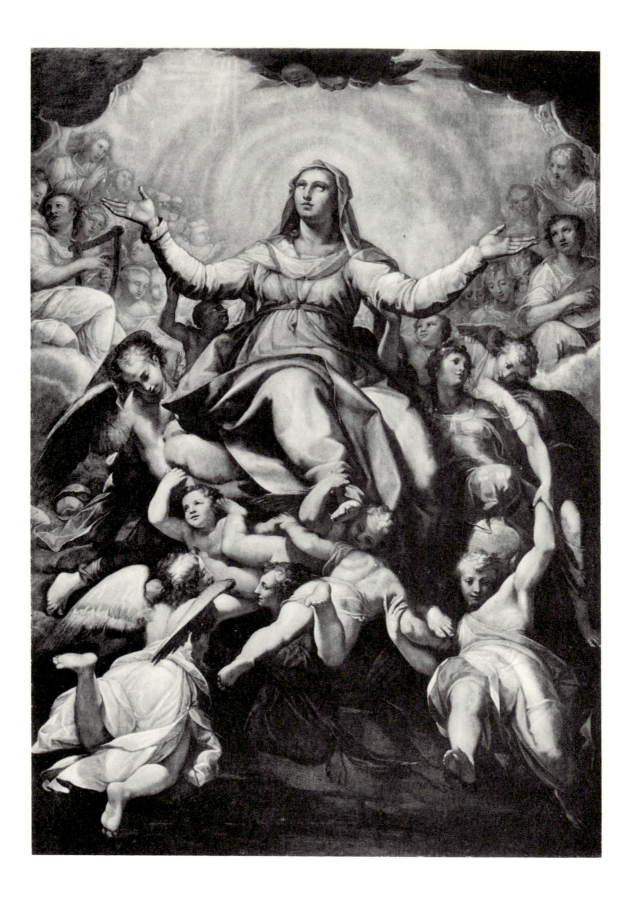

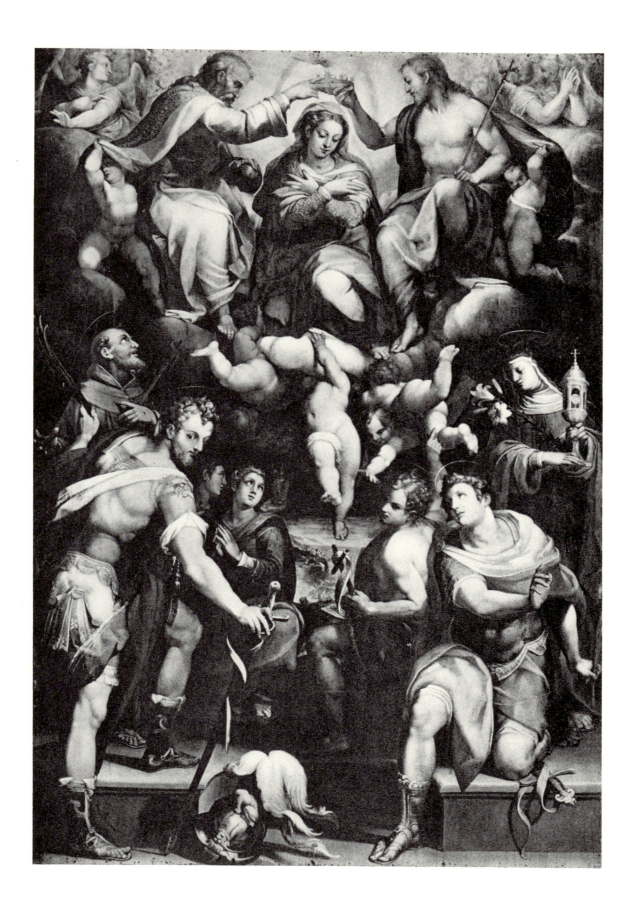

84

PELLEGRINO TIBALDI
Adoration of the Shepherds
GALLERIA BORGHESE. ROME

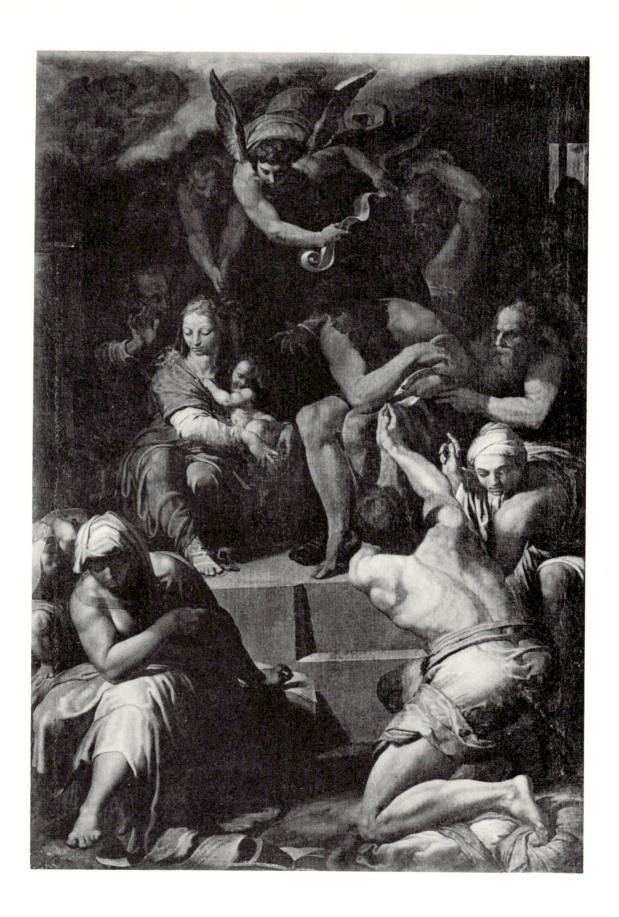